IMAGES
of America

HALCYON

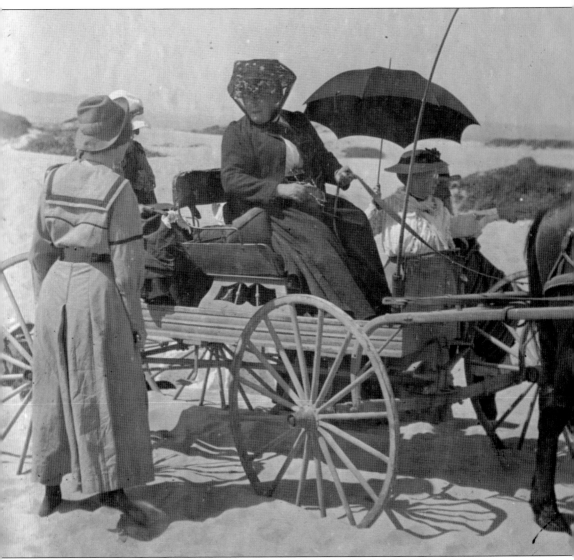

Francia A. LaDue (center), cofounder of the Temple of the People, chats with others after arriving at Oceano Beach for a temple picnic. The very independent leader often visited around the area at the reins of her one-horsepower, four-wheeled surrey. The beach was a favorite gathering spot for the group, as it is today. (Courtesy of the Temple of the People archives.)

ON THE COVER: The Temple of the People congregation gathers for a Sunday photograph outside the Blue Star Memorial Temple in 1927, three years after the building was completed. The landscaping has not been completed, and the trees behind the structure are small. From left to right are Otto Westfelt, unidentified, George Miller, John O. Varian, unidentified in hat, Polly Tarbox, Duncan Ferguson, Ida Mae Wilkins, Grace Hillyard, Dr. William H. Dower, Amy Ontiveros, Fred Whitney, Augusta Volz, ? Clemm, Glenn Tarbox, ? Clemm, and two unidentified. (Courtesy of the Temple of the People archives.)

IMAGES
of America

HALCYON

Eleanor L. Shumway and Karen M. White

ARCADIA
PUBLISHING

Published by Arcadia Publishing
Charleston, South Carolina

Printed in the United States of America

Library of Congress Control Number: 2018939614

For all general information, please contact Arcadia Publishing:
Telephone 843-853-2070
Fax 843-853-0044
E-mail sales@arcadiapublishing.com
For customer service and orders:
Toll-Free 1-888-313-2665

Visit us on the Internet at www.arcadiapublishing.com

Halcyon is dedicated to the founders and to all the residents before us who have created the place we all call home.

CONTENTS

ACKNOWLEDGMENTS

This book has been a labor of dedication, gratitude, and love of the place we call home. The authors wish to acknowledge those from our town who have generously contributed time and skills to its creation, including Marti Fast, Kathy Schmuch, Jan Scott, Patte Nolen, Debra Rowlands, Anne Dunbar, Nashoma Carlson, and Barbara Norman.

Photographs and information were gleaned from the archives of the Temple of the People, the Schussman family, residents and friends of Halcyon, and Varian Inc. Unless otherwise noted, all images appear courtesy of the archives of the Temple of the People.

Most notably, the authors recognize Dr. Paul Eli Ivey, professor of art history at the University of Arizona, Tucson, for his unwavering encouragement of our efforts to preserve Halcyon's history.

INTRODUCTION

A new cooperative colony was established in the Arroyo Grande Valley of California in 1903. Its founders were directed to a rural setting nestled between Arroyo Grande and Oceano on the Central Coast of California. They called the place Halcyon, a Greek word meaning peaceful and calm.

"Organized by a new theosophical movement called The Temple, it was an attempt to practice the Christian Golden Rule in a communal setting of liberty, equality, and fraternity," writes historian Paul Ivey in his 2013 monograph *Radiance from Halcyon, A Utopian Experiment in Religion and Science*; he is one of several scholars of religion and communal settlement to study the group since the 1960s.

The accomplishments of the Temple of the People in the 20th century tell a story of foundational work filled with sacrifice, idealism, dedication, frustration, tolerance, learning, joy, and love. Some people have come to Halcyon expecting a utopia inhabited by saintly beings and have left deeply disappointed. They found a group of ordinary human beings with ordinary strengths and weaknesses, united by a desire to live the Golden Rule (Do unto others what you would want them to do unto you), knowing that love can and does transcend all eventually. It is a simple ideal and a difficult assignment, but it is one that all work on and one that nourishes as it challenges the very best within each human being.

The historic town of Halcyon is the home of the Temple of the People. Although not everyone who lives here is a member, most are dedicated to the ideals of the Golden Rule, and that atmosphere is contagious. As you walk through this visual history, you will see people from across the years living out and working on these ideals.

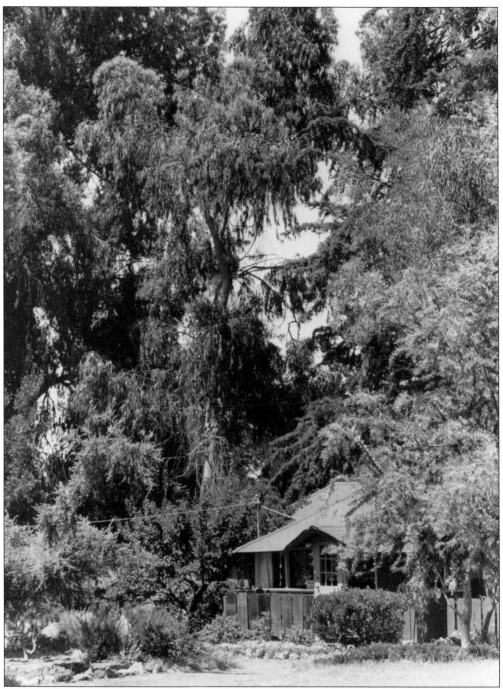

Halcyon is tucked between the urban streets of Arroyo Grande and the open expanse of vegetable fields of the La Cienaga Valley, providing a bucolic refuge for people, animals, and birds. Massive eucalyptus, cypress, pine, and acacia trees tower over this modest redwood bungalow in the community. The eucalyptus groves in Halcyon were planted in 1911 with the hope that the wood could provide building material in the years to come. This proved unsuccessful, but the trees provide a preferred nesting site for red-tailed hawks.

One

A Historic District

The historic town of Halcyon is tucked between the cities of Arroyo Grande and Oceano, halfway up the coast of California. It was established in the wave of theosophical and utopian agricultural settlements that moved out from the East Coast from the late 19th century into the early 20th century and remains true to its name as a place of relative peace, calm, and inner focus that its founders and original members would recognize today.

In 1903, five years after Dr. William H. Dower and Francia A. LaDue formed a theosophical group in Syracuse, New York, the two were directed to expand their work by moving west. They purchased a farmstead about 15 miles south of the train depot in San Luis Obispo and two miles from the ocean as the crow flies. This place, called Halcyon, became the permanent home for the Temple of the People and the intentional community established for its growing membership.

The townsite was located on acreage known as the sand hill region of the lower Arroyo Grande Valley, where the fertile alluvial clay from the flooding Arroyo Grande Creek cuts into the western edge of the sandy hill land east of the ocean beaches. The original farmer grew grains on the flatland beginning in 1884 and soon added apricot trees and berries on the hill. Since then, the area has expanded its reputation as one of the richest crop-growing areas in the United States, where strawberries bring in millions of dollars and the land produces broccoli, cauliflower, and celery year-round.

Constructed by original community members, homes in the 130-acre settlement are unique, many with nods to Craftsman-style architecture. They have been maintained and repaired by generations of temple members and residents.

Life in the village revolves around the services, study classes, and mission of the Temple of the People, which is to create a place where the Golden Rule and the practice of brotherhood are paramount. Halcyon was recognized in 2017 both as a national historic district by the US Department of the Interior and as a state historic district by the State of California.

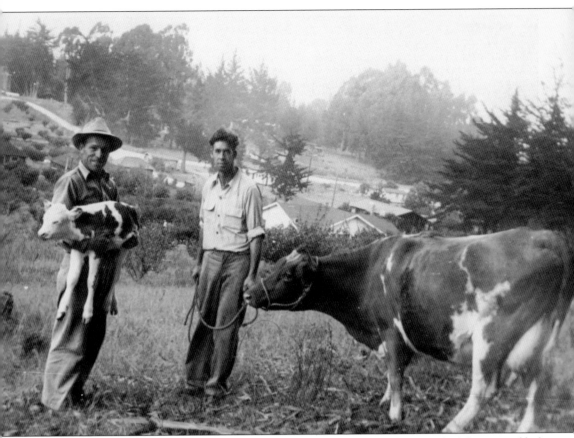

Kenneth R. Shumway (left) and neighbor Eric A. Varian celebrate the arrival of the new calf of Missy the milk cow in 1943. Cow owner Shumway carries the newborn as they pause in Missy's pasture on the southwest hill overlooking the village of Halcyon. Behind them are some of the many apricot trees planted when the area was first developed as a farm.

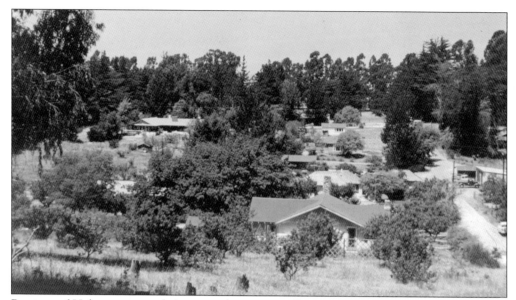

Portions of Halcyon are nestled among the trees, as illustrated in this photograph taken from the southern end of Helena Street around 1950. The gravel streets are yet to be paved by San Luis Obispo County. In the foreground are remains of the apricot orchards planted before 1900. Eucalyptus trees in the distance line the northern boundary of the community.

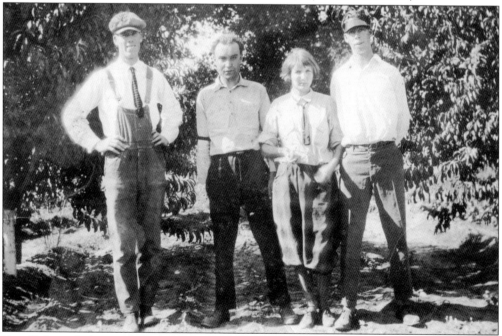

Four Halcyon kids pose for a photograph in the late 1920s. From left to right are Russell Varian, Herman Volz, Evelyn Elliott Carlberg, and Eric Varian. All four came to Halcyon in their teenage years. Russell Varian went on to develop one of the first major electronics firms in Silicon Valley. Volz stayed in Halcyon for his lifetime and ran the community waterworks. Carlberg also lived the rest of her life in Halcyon, dedicating much effort to community affairs. Eric Varian became a local electrical contractor.

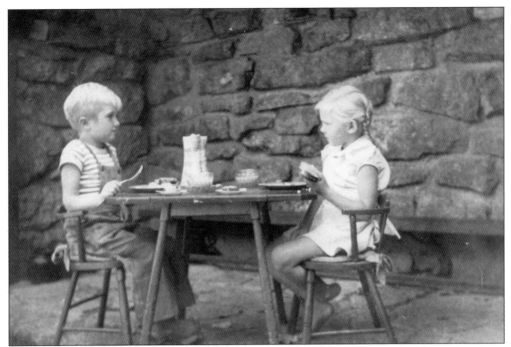

Holding a tea party in the backyard of the Carlberg home around 1947 are Carl Carlberg (left) and Susie Lentz Clark. They are just inside a small rock garden shed built by Carl's father, Henry Carlberg. The shed was a focus of the rock-walled back garden. Henry Carlberg made use of tufa, a golden volcanic rock found in the nearby hills, for his work.

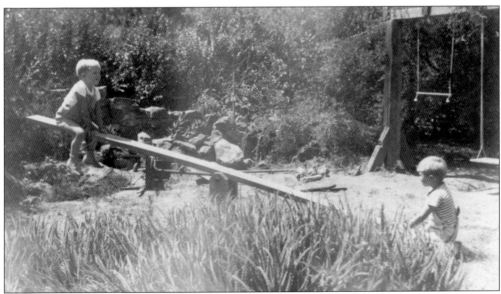

Carl Carlberg (left) and friend and neighbor Jim Long play on Carlberg's homebuilt teeter-totter in the backyard. Halcyon parents found creative ways to provide recreational outlets for their youngsters, such as this long board attached to the center pivot. Also available were swings strung to trees and long ropes that enabled youngsters to swing from tree to tree Tarzan style.

Three members of the Halcyon community meet behind leader Francia LaDue's cottage to show off their canine companions in 1926. The moment of levity is shared between, from left to right, Edward Twistman, Herman Volz, and Gene Ficke. The cottage was replaced in the 1950s.

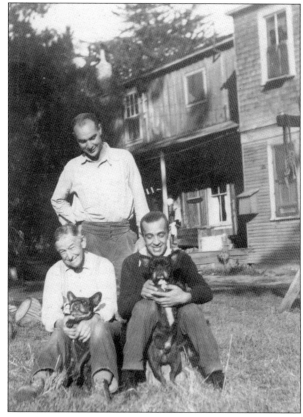

A group of temple builders and their adult associates gather for an open-air meeting in the eucalyptus grove east of the sanatorium to begin building an outdoor gym in May 1905. The plan was to add swings and rings and put in rustic benches and chairs for those who might want to visit the site. From left to right are (first row) William W. Kent and baby Florence Kent Harrison, ? Tschugi, and Bartram Kent with dog Bruno; (second row) Andrew Mecchi, Clayton Conrow (on horse Nellie), Georgina Jones, Byron Kent (on horse Dollie), ? Lacefield, Gwynneth Conrow (in swing), and Jane Kent.

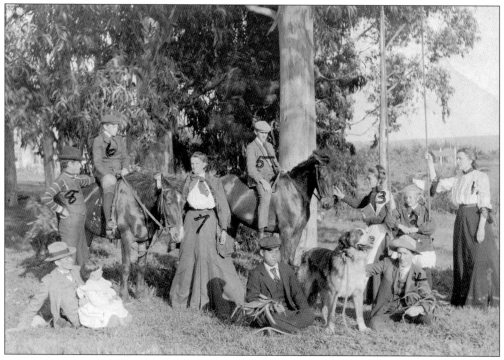

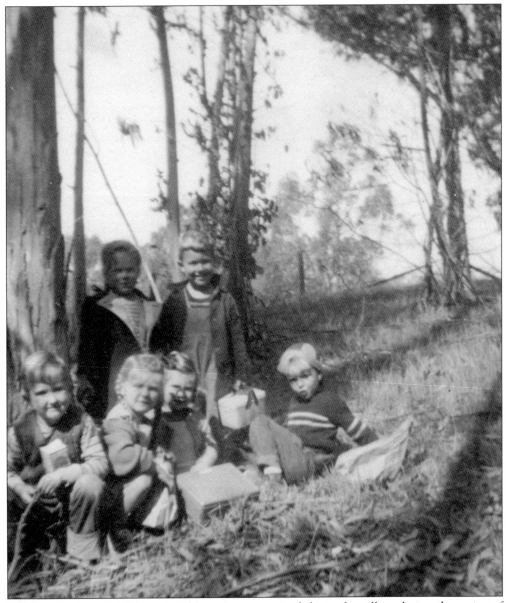

The preschool-aged children of Halcyon enjoy a nature hike in the village during the spring of 1948. Temple member Joyce Hedin taught them in a kindergarten-like program. From left to right are (seated) Carl Carlberg, Susie Lentz Clark, Patty Lentz Dana, and Jim Long; (standing) Barbara Shumway Reed and Gary Ross.

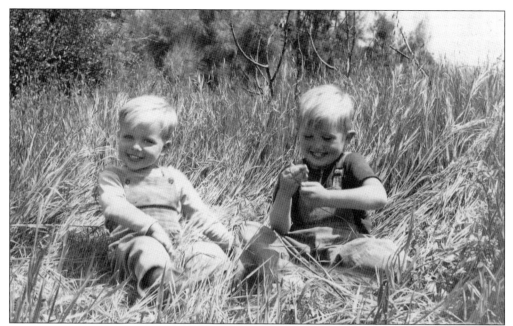

Playmates Jim Long (left) and Carl Carlberg are almost hidden in the grasses and wildflowers that grow between their Halcyon homes in 1947. Today, strict fire codes require such growth to be mowed down. However, Halcyon children are still welcome to play in the community's open spaces.

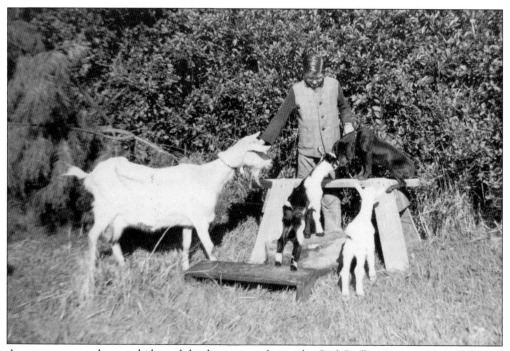

A pet nanny goat, her two kids, and the dog get together under Carl Carlberg's supervision. Halcyon's rural zoning has always allowed residents to keep animals, including milk goats and cows, ponies and horses, chickens, ducks, and other fowl, and even an occasional 4-H project pig.

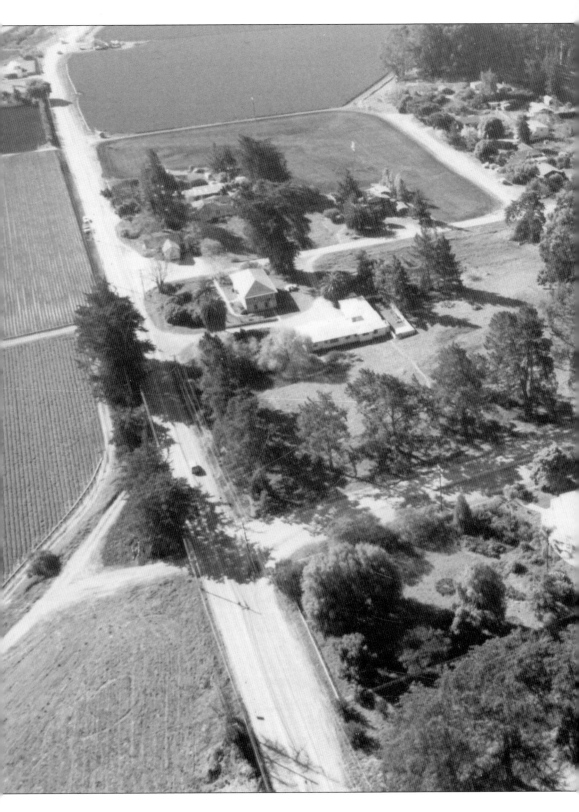

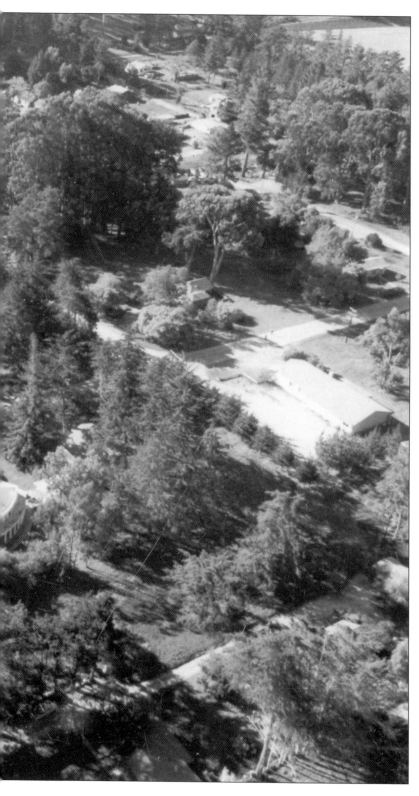

This aerial view of the village of Halcyon in January 1986 shows that most homes are hidden by trees. The Blue Star Memorial Temple is easily recognized by its triangular roof. The Halcyon Store, William Quan Judge Library, and Central Home can be seen at center to the right of Halcyon Road, which runs from top to bottom on the left. The Hiawatha Lodge is at far right center. This photograph also shows the expansive farm fields surrounding the community.

Map 1. Assessor's Map County of San Luis Obispo, Unrecorded Survey, 1906

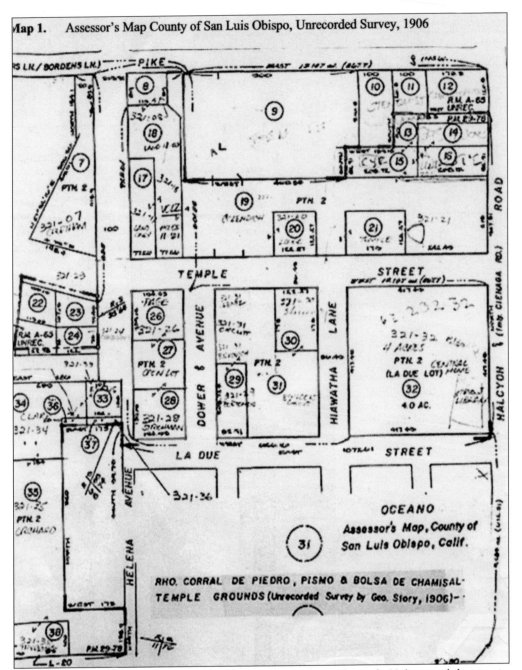

Part of an assessor's map from San Luis Obispo County shows the early Halcyon subdivision in 1906. The community is made up of about 16 square blocks of land.

18

Youngsters of the Halcyon community made a beeline to the sandy shore of the Arroyo Grande Creek during a summertime barbecue trip to Routzahn Park, east of Arroyo Grande. Shown clowning around are, from left to right, (first row) Buck Ross, Carl Carlberg, Patty Lentz Bennett, and Roselma Shumway Quinn; (second row) Eleanor Shumway, Robert Shumway, Mona Lee Schussman Kelly, and Gloria Shumway Quale.

Some of Halcyon's highways and byways are mere trails in the sand. When Halcyon was first subdivided in 1906, all of the roads were dirt. Gravel was added and, at long last, paving arrived for some. No curbs, gutters, or sidewalks are to be found, because the community desires to keep Halcyon in its near-historic state.

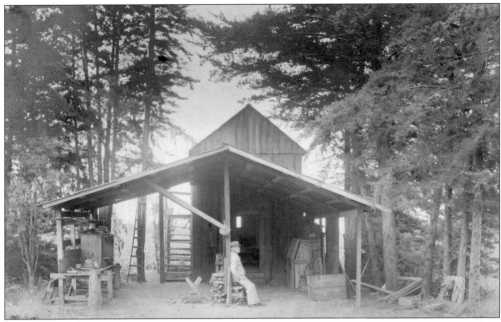

Temple of the People scribe Charles H. Harris sits on a stack of firewood in front of the shed formerly located behind the old temple administration building at the corner of LaDue Street and Halcyon Road around 1915. Harris at rest was a rare sight, as he was known for his energy and projects. The shed housed tools for maintenance and woodworking projects.

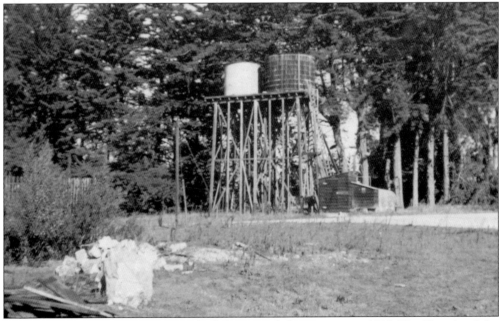

Halcyon has its own water system, which has served the town since 1903. The Temple of the People drilled a well on a hillside location to serve the Open Gate and another cottage no longer extant. A windmill and elevated storage tanks on the hill beside the well delivered the water via a gravity system. Later, a gasoline engine was added to power the pump. The community is now part of the Oceano Community Services District for fire protection and some water services.

Dr. William Dower (left) and Charles H. Harris discuss maintenance at the old two-story Temple of the People office building around 1915. The wood-framed building remained in use through the 1920s before being replaced by more permanent structures.

Around 1910, early Halcyon workers use horse power to till the soil for gardens to the east of the John Varian home. This area between the Varian home and the lodge was used for growing food and herbs.

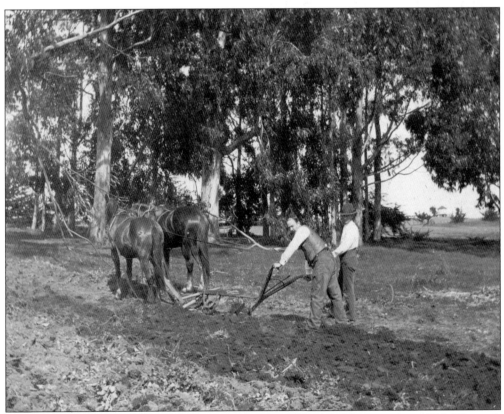

Ground is broken for a vegetable garden near the Halcyon Hotel and Sanatorium in 1910. The work is being done by Dr. Dower (left) and Clarence Dennis with their equine helpers. The site was known as the Spring Block because of a naturally occurring artesian spring used to irrigate crops.

Two members of the Tedford-Brown family are shown packing apricots for sale in their own backyard. What is now Halcyon was first planted as a large apricot orchard prior to 1900, and Halcyon residents reaped the benefits for many years. Ralph Brown (left) sits on a crate while daughter Lillian Brown Horskey works standing in the 1950s.

Apricot trees bloom beside the Hiawatha Lodge in the spring around 1928. Dry-farmed apricot trees were abundant in Halcyon, as the site was originally a farm. Trees at this site were removed for the lodge parking lot.

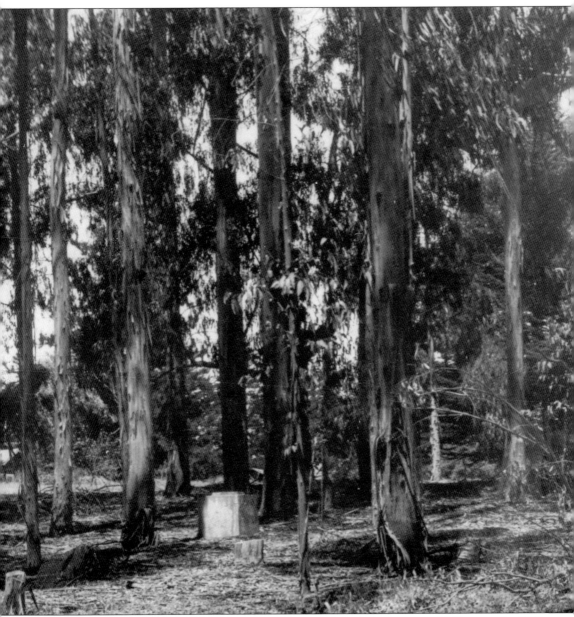

The Builders Grove, a center point in the village of Halcyon, was created following the 1922 death of Francia LaDue, the first guardian in chief. A concrete cube marker was placed in the grove by the temple builders youth group in honor of LaDue.

Two

THE TEMPLE OF THE PEOPLE

While studying medicine in New York City, William Dower met the cofounder of the Theosophical Society, William Quan Judge, and became interested in theosophy. He organized a branch of the society in the early 1890s, and not long after, Francia LaDue became a member. The two worked closely together and in 1898 were asked by their spirit guide, Master Hilarion, to establish the Temple of the People. LaDue, who was also known as Blue Star, became the first guardian in chief.

When Dr. Dower was instructed to relocate his medical practice to the West Coast, Blue Star made two trips to California to investigate several healing centers designated by the master. She was ultimately directed to a place just east of Oceano, and the site was dedicated to the temple work in January 1903. The doctor, and those of the original Syracuse group who could so arrange their affairs, came to join her in this place called Halcyon.

They purchased a three-story Victorian home, naming it the Halcyon Hotel and Sanatorium, and opening Dr. Dower's medical practice. His was the first X-ray machine on the Central Coast, along with cutting-edge therapies including color vibration, sound, and electricity. Patients were treated without regard to financial status, but pleas in the temple's magazine sought sponsors at $10 per month for residential treatment.

In addition to the focus on the healing arts, there was an interest in establishing other opportunities to earn a living. Although an intentional community, Halcyon was never a commune, and its members have always supported themselves in family groups.

In 1908, the temple was incorporated in California as "The Guardian in Chief of the Temple of the People, a Corporation Sole," with headquarters at the new townsite. The Temple of the People today is a thriving worldwide philosophical and spiritual organization whose tenets include "Creeds Disappear, Hearts Remain," "Judge Not, Lest Ye Be Judged," and the Golden Rule. Nondenominational, its members and friends come from a wide variety of religious backgrounds.

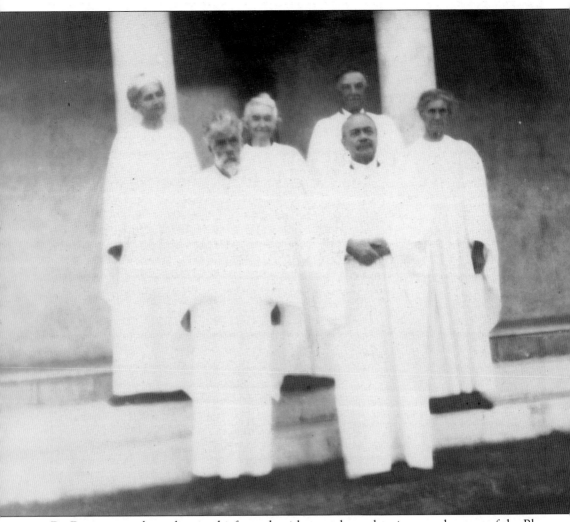

Dr. Dower, second guardian in chief, stands with several temple priests on the steps of the Blue Star Memorial Temple around 1927. From left to right are Jane Dower, John Varian, Ida Wilkins, Dr. Dower, Harry Harrison, and Agnes Varian.

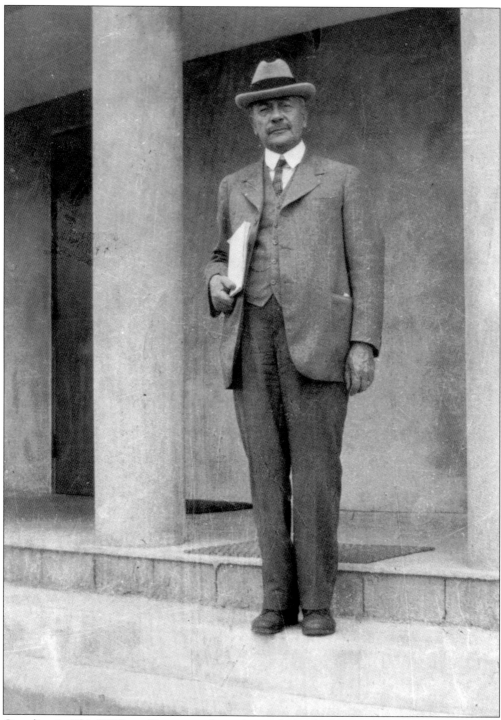

Guardian in Chief William Dower stands on the newly finished steps of the Blue Star Memorial Temple in 1925. Dower relocated his medical practice to Halcyon when he moved from Syracuse in 1903. Besides having the first X-ray machine on the Central Coast, his treatments included color, sound, and electricity.

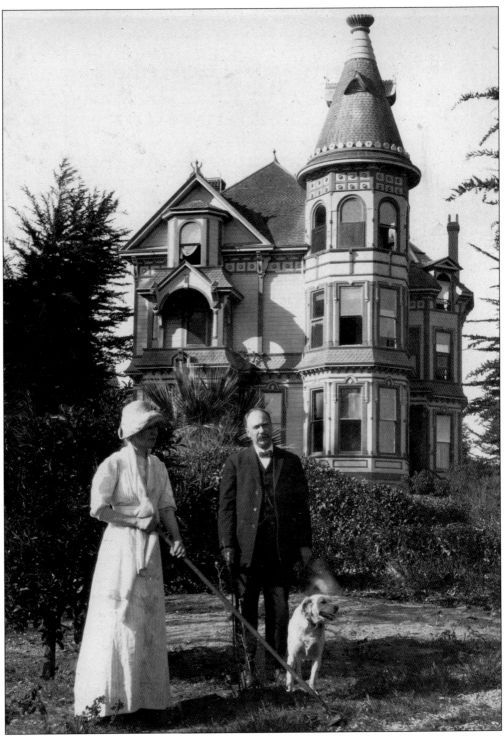

Jane Kent Dower (left) and Dr. Dower stand in front of the three-story Victorian house in Oceano purchased by the Temple of the People in 1904 to serve as the Halcyon Hotel and Sanatorium. The building still stands along State Highway 1 but was sold by the temple in 1949.

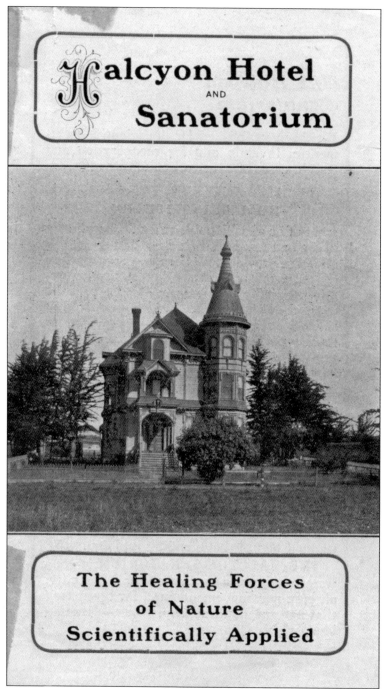

Halcyon Hotel
AND
Sanatorium

The Healing Forces
of Nature
Scientifically Applied

This c. 1910 brochure for the Halcyon Hotel and Sanatorium tells of the treatments available. It states: "Drugs are used conservatively. All remedial agents that medical science and experience have proved valuable—the resources of nature, as sunlight, pure air and water, baths, the use of oils, electricity, the natural radio-active forces that nature has conserved in the vicinity, and equally if not more important, the mental and moral forces—are drawn upon and applied, under the direction of skilled physicians for the restoration and preservation of health."

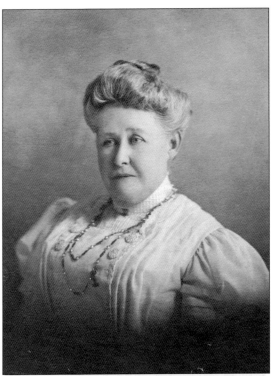

Francia LaDue, known as Blue Star, was the first guardian in chief of the Temple of the People. She helped establish the philosophical and spiritual organization in 1898. Later, she traveled west to the Central Coast of California to find the site that is now Halcyon.

Before vehicular travel became common locally, Dr. Dower used his faithful horse for transportation from Oceano to Halcyon and beyond. "Doctor," as Dower was called by temple members, focused on the treatment of drug addiction, alcoholism, nervous disorders, and tuberculosis.

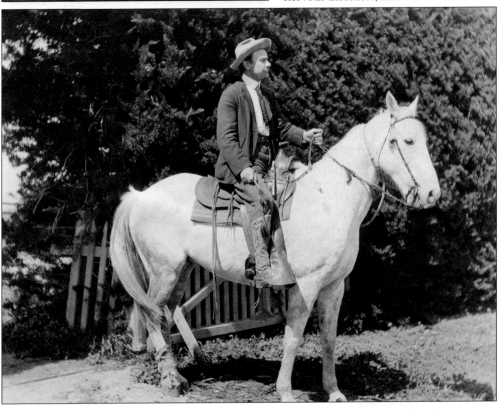

Dr. William Dower, known as Red Star, served as the second guardian in chief of the Temple of the People. One of the founders, he established a healing center in Oceano to which people came from all over the world for help.

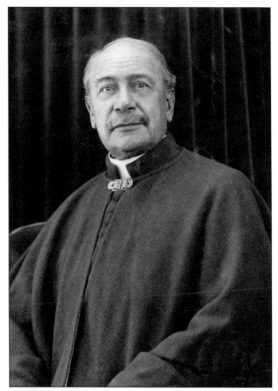

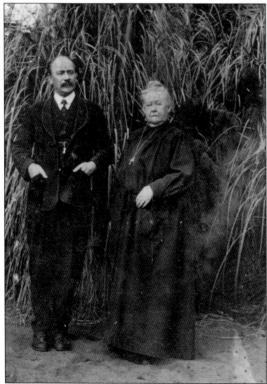

Dr. Dower and Francia LaDue, cofounders of the temple, stand on the grounds of the sanatorium, a health facility established by Dr. Dower for the treatment of mental and physical illnesses. LaDue died in 1922, the year after this photograph was taken. Dower succeeded her as leader.

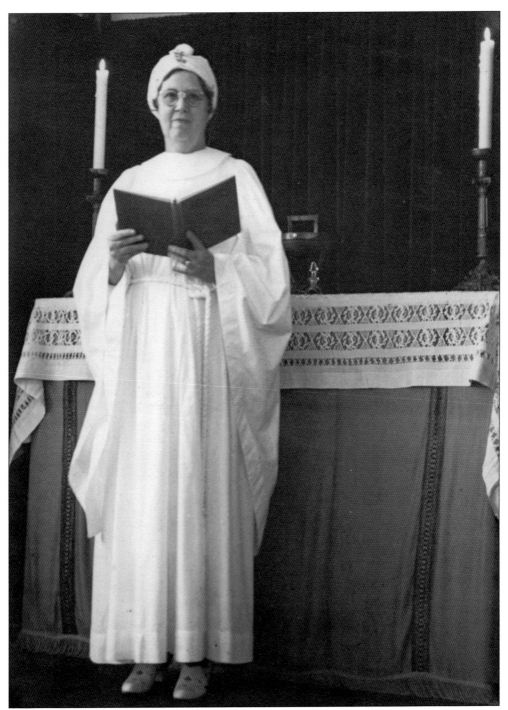

Pearl Frances Dower, known as Gold Star, served as third guardian in chief of the Temple of the People from 1938 until her death in 1968. She is credited with guiding the temple through difficult times, including the end of the Great Depression and World War II.

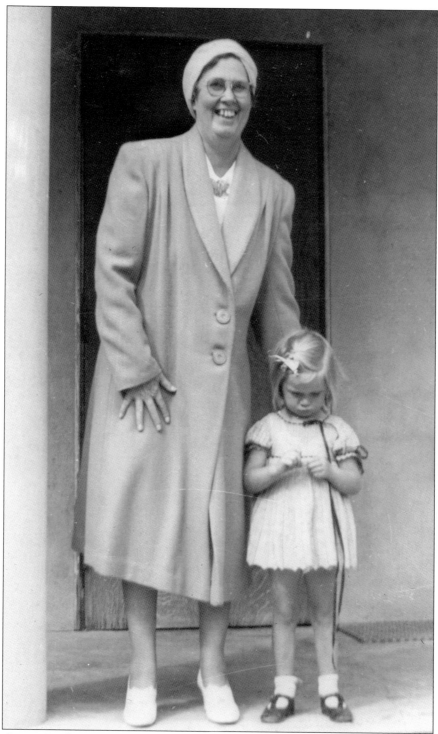

A very happy Pearl Dower, the third leader of the temple, stands on the porch of the Blue Star Memorial Temple with Susie Lentz Clark around 1950. Dower took an active interest in programs for the children of Halcyon and was the godmother of Clark.

Guardian in Chief Harold Forgostein (left) and Anora Gibson, temple priest, enjoy a conversation with Mindee Thyrring, a recent arrival in Halcyon. This Sunday event in January 1983 came after Thyrring's naming ceremony in the Temple of the People.

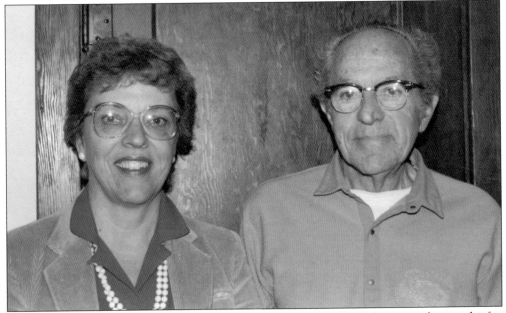

Two temple leaders are shown in January 1987. Harold Forgostein (right) was guardian in chief at this time, while Eleanor L. Shumway served as inner guard. Shumway became guardian in chief upon the death of Forgostein in March 1990.

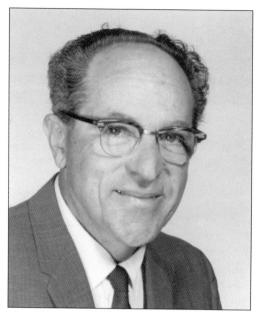
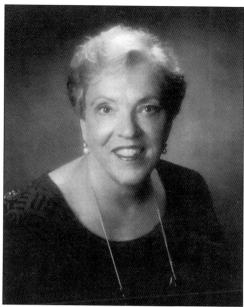

Harold Forgostein (left) served as the fourth guardian in chief from 1968 to 1990 and was known as Violet Star. Born in Marquette, Michigan, in 1906, he graduated as an artist from the Carnegie Institute of Technology (now Carnegie Mellon University) in Pittsburgh, Pennsylvania. Forgostein moved to New York City in 1929, just in time for the stock market crash, and found work as an artist for the WPA during the Great Depression. He joined the temple in 1934, moved to Halcyon in 1941, and became a teacher in the early 1950s. Eleanor Shumway (right) became the fifth guardian in chief of the temple in 1990. A retired public school teacher and former two-time Peace Corps volunteer to Ethiopia, Shumway is known as Green Star. Her family moved to Halcyon in 1942, and she grew up in the community. Shumway continues to serve in her leadership role.

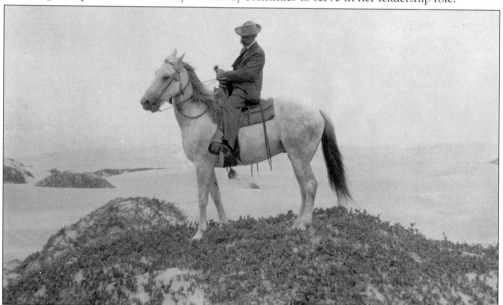

Dr. Dower, on his trusty grey horse, takes time to ride the dunes in Oceano. The Oceano dunes drew people for solace and comfort even in the early years of the 1900s.

Guardian in Chief Eleanor Shumway is mobbed by younger members of the Halcyon community during a social event in one of the town's cottages. Now adults, the children are, from left to right, Alex Moiseyev, Julia Moiseyeva Smirnova, Anna Moiseyeva, and Alona Veller Sauzade.

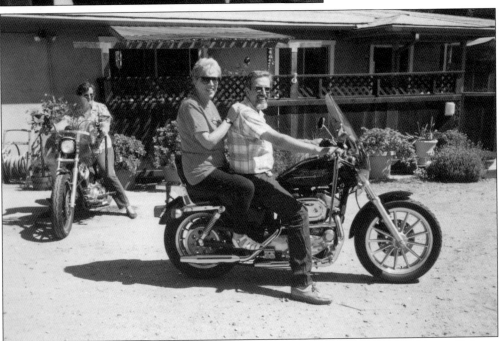

Eleanor Shumway (center) climbs up behind Ed Schmuch as he and wife Kathy (left) visit Halcyon on a motorcycle tour in early 2000. The welcome sign is usually out for visitors who wish to learn more about the historic community.

The porch of the Blue Star Memorial Temple often draws people for a photo opportunity. These guests were temple members visiting from Germany. The photographer is Jurgen Scheutzow, from Hamburg (far left). From left to right are Fritz Ammon from Berlin and Carolyn and Harold Forgostein from Halcyon.

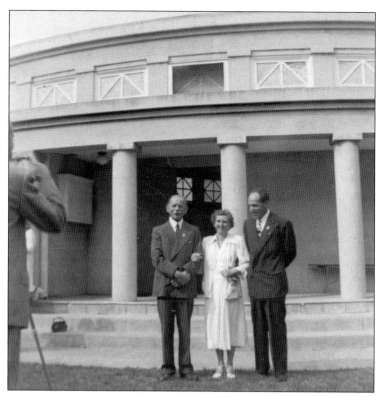

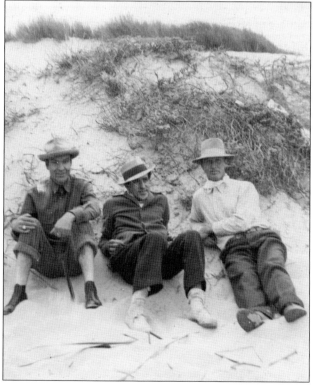

Three members of the temple rest on a sand dune during a community outing to Oceano Beach in the 1940s. From left to right are Herman Volz, who established a large egg farm in Halcyon; Harold Forgostein, artist and later guardian in chief; and Cethil Mallory, pianist, carpenter, and cabinetmaker.

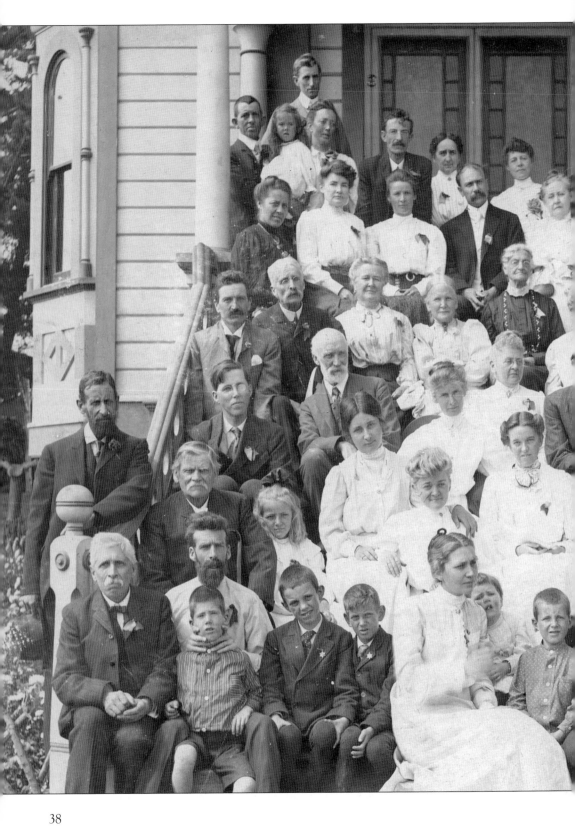

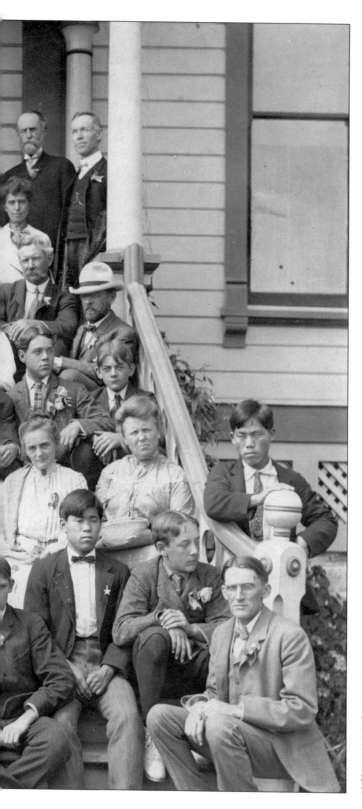

Temple members gather on Sunday morning, August 4, 1907, on the steps of the Halcyon Hotel and Sanatorium for an official convention photograph. Since its founding in 1898, the congregation has gathered each first week of August for services, presentations, and social events. The *Temple Artisan* magazine stated, "There was a larger attendance at this eighth convention than at any previous convention of temple members." Although individual identities fade with time, the group spirit is still alive in the community's activities.

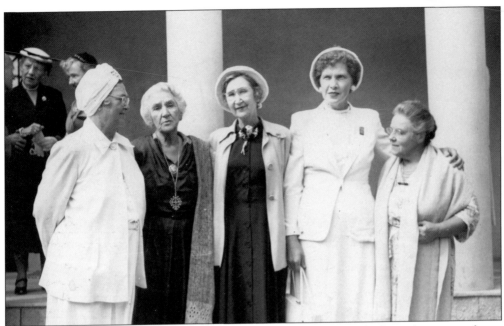

Dressed in their Sunday best, this group of temple members visits below the porch of the temple after Sunday services in 1950. From left to right are Guardian in Chief Pearl Dower, Louise Awerdick, Gertrude Tedford, Roberta Shumway, and Aileen Harrison.

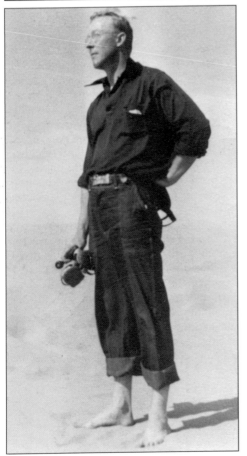

Sociologist, writer, and temple member Elmer Hedin takes off his shoes to enjoy the sand between his toes during a visit to the local beach during the 1940s. Among the lines he wrote in *The Hearts of Men*, a book of selected poems, are: "Give me an hour of Life, unshackled strength / To work my will, erect upon these sands / Furrowed by fear-bound writings, here at length / To see perfection rise beneath my hand."

Three

THE BLUE STAR MEMORIAL TEMPLE

Creating a sanctuary structure that would express the physical embodiment of its ideals was central to the temple group's work from its earliest days. Dr. Dower envisioned the temple architecture as an expression of sacred mathematical and geometrical symbolism, representing an ordered universe and dedicated to the service of humanity. Sited atop a gently sloping Halcyon hillside with a view of the distant Oceano dunes, it would be named the Blue Star Memorial Temple in honor of Francia LaDue, the temple's first guardian in chief.

LaDue died in 1922, but her bequest for construction of the temple energized the membership. Dower shared his vision for the singular structure with prominent Southern California architect and temple member Theodore J. Eisen, who embraced the project. A ceremony initiating the endeavor was held on the anniversary of Blue Star's birth, January 19, 1923, when the group gathered to lay the center stone. Plans were drawn, discussed, and finalized by March, and construction began in April.

Three-sided buildings are unconventional, and this one—a convex equilateral triangle with gently bowed sides—is more easily recognized from above as being heart-shaped. The structure symbolizes the center point in all expressions of life, from microcosm to macrocosm, connected together as one. An encircling band of clerestory windows diffuses sunlight into the sanctuary through the soft glow of opalescent glass, representing the light of God flowing in from above.

Everyone hoped construction would be complete in time for the annual August convention, but the challenging architecture included curved walls, seven doors, 26 complex windows, a pillared porch encircling the building, and three major beams spanning upward from the corners to the center point of the ceiling. Despite the fact that everything required more skill and time than they had imagined, the roofless temple was consecrated on August 12, 1923. Sadly, Eisen died seven months later and never saw the building's 1924 completion.

Members carried their own chairs to services until the 1925 convention, when donations of time, materials, and money finally allowed flooring and furnishings to fulfill the vision for the temple sanctuary.

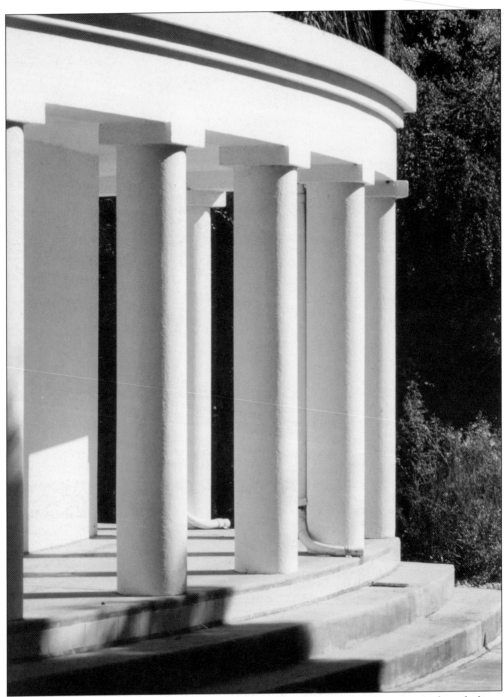

The Blue Star Memorial Temple was built on lines of mathematical and geometrical symbolism, like other sacred constructions such as Stonehenge, the pyramids of Egypt and Mexico, and the cathedrals of Europe. Shown here is the porch, supported by 36 pillars, 12 on each of three sides. Twelve is the product of three and four, which, added together, make seven. Thirty-six is the product of twelve and three, the number of the Trinity. Each pillar is seven feet high and 13 inches in diameter. Thirteen is the symbolic number of Christ (one surrounded by the 12 disciples).

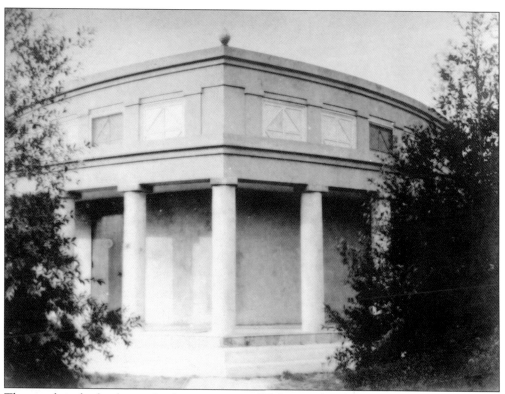

The temple is the focal point for the community of Halcyon. The whitewashed sanctuary is shown here in the late 1920s (above) and from about the same vantage point in 2015 (below) with a new coat of bright white paint.

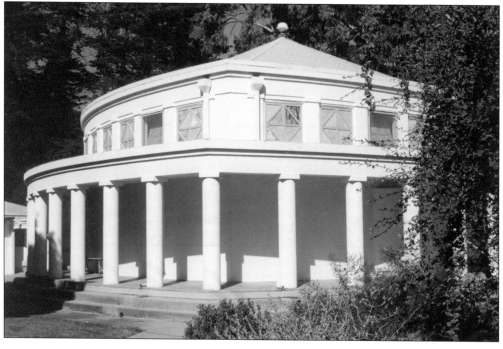

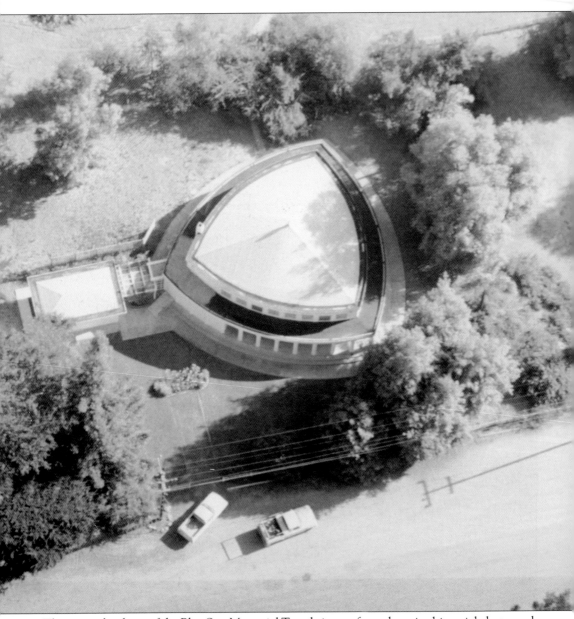

The triangular shape of the Blue Star Memorial Temple is seen from above in this aerial photograph taken in the 1970s by hot air balloon enthusiast Gordon Bennett of Arroyo Grande. He often launched his multicolored balloon from the field across from the temple with Halcyon residents as ground crew.

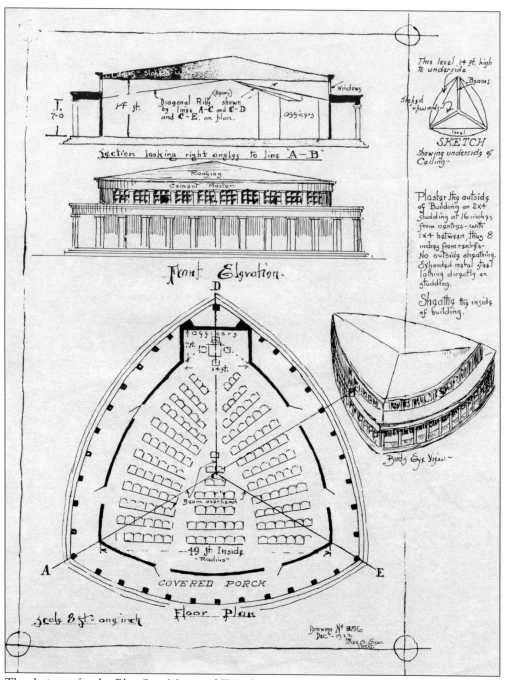

The designer for the Blue Star Memorial Temple was prominent Southern California architect Theodore Eisen. Eisen, a temple member, was hired to bring the inspiration and direction of Dr. Dower into manifestation. This drawing was created in 1922 as planning began. The sanctuary, completed by August 1924, was Eisen's last project, as he died six months before the building was finished.

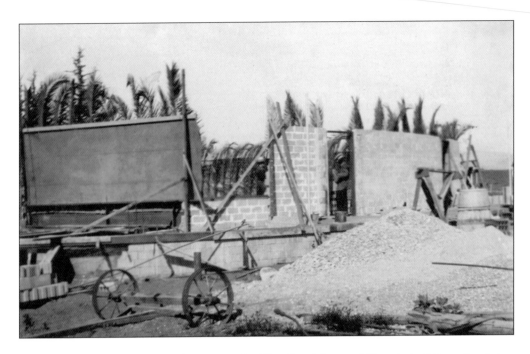

Interlocking concrete blocks pile up near the Blue Star Memorial Temple building after being formed at a manufacturing site two blocks east, along the Arroyo Grande Creek. The center stone, a perfect three-foot concrete cube, was laid and dedicated on January 19, 1923, the birthdate anniversary of Blue Star, Francia LaDue. Into the open heart of this cube were placed temple records, holy writings, and books representing all religions. The evening dedication ceremony included messages, music, and a ceremonial bonfire.

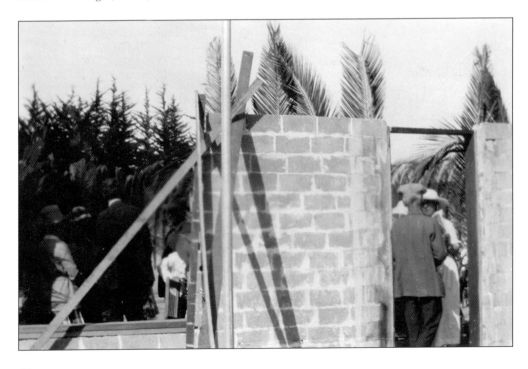

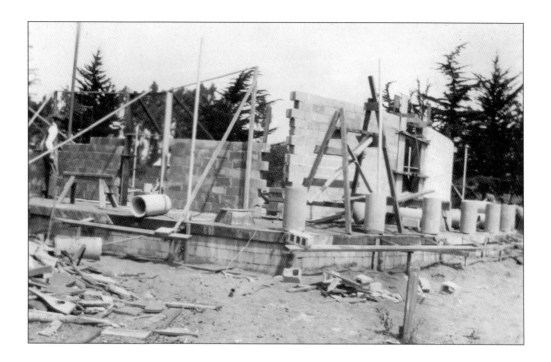

The Blue Star Memorial Temple rises from the sand in these pictures from 1923. The pillars shown were first formed in section tubes, set in place, and then filled with concrete to reach their final height of seven feet. Beginning in April and supervised by Perry More, volunteer and paid workers helped with construction. Among those working on the project were the men who had set the center stone, William H. Townsend, Claude Bardrick, Harry Elliott, and Clarence Dennis. Other workmen included A.E. Ontiveros, Lucien Salanave, and Herman Volz, with younger helpers Eric Varian and Lincoln Wictus.

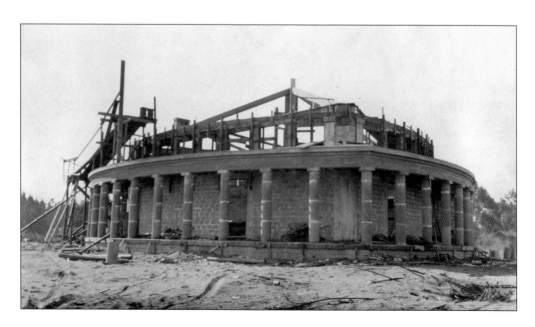

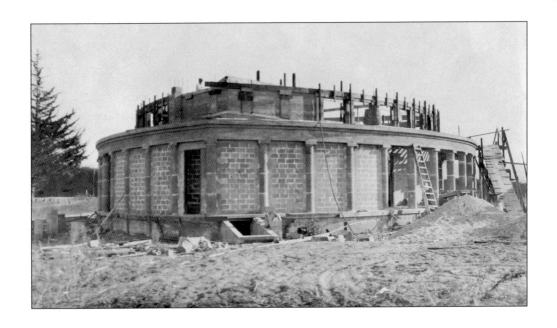

While workmen constructed the Blue Star Memorial Temple, the membership worked to fund the project. Starting with an original donation of $2,900.93, the special savings deposit account in the Bank of Arroyo Grande showed a total of $3,527.12 by May 20, 1923, according to the *Temple Artisan* quarterly magazine. Donations allowed the $10,000 building project to be completed with no debt.

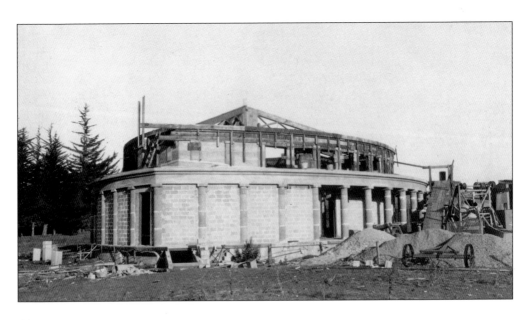

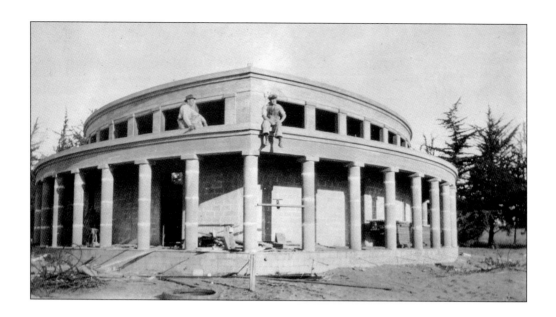

Above, Perry More (left), project supervisor, and the young Herman Volz, a willing volunteer, take a break on top of the nearly completed Blue Star Memorial Temple in 1924. More is credited with changing the original plan from a wooden building to concrete, giving the structure more permanence. Below, the temple's east gardens begin to take shape in late 1925.

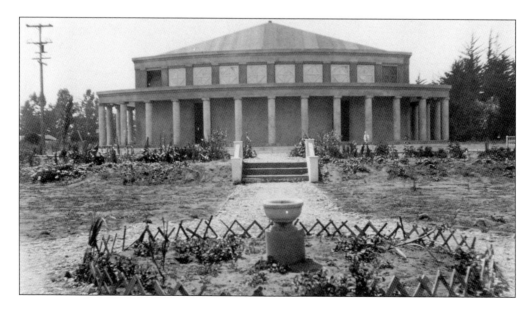

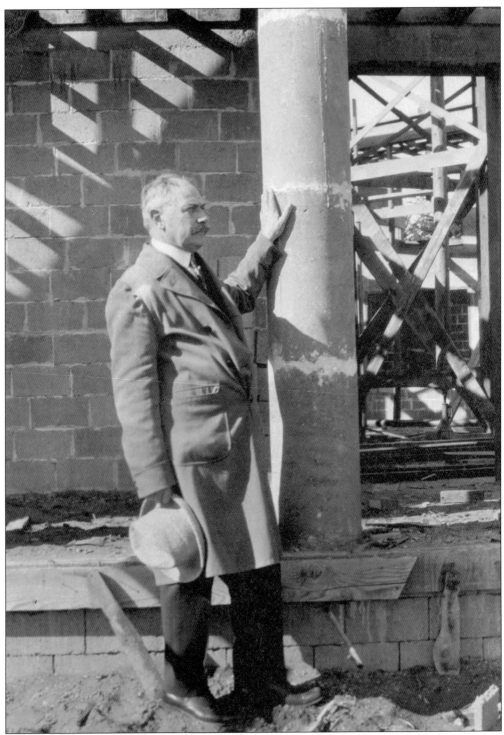

Dr. Dower, second guardian in chief, inspects the site as the Blue Star Memorial Temple slowly takes shape. He leans against one of the 36 pillars that circle the building. The sectional construction of the solid concrete pillars can be seen here.

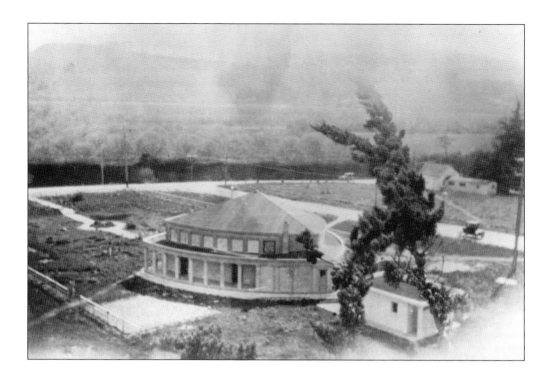

Two early views show the newly completed Blue Star Memorial Temple. The photograph above was taken around 1926 by Sigurd Varian, an early barnstorming pilot. The road running left to right is Halcyon Road, shown at its intersection with Temple Street. The Halcyon Store can be seen at its first location on the right. Below, a profusion of blue lupine covers the sandy hillside, framing the temple building in the background, around 1927. The path through the flowers at left leads from the temple to the Halcyon Store and Post Office, located at that time a half block north of the present location.

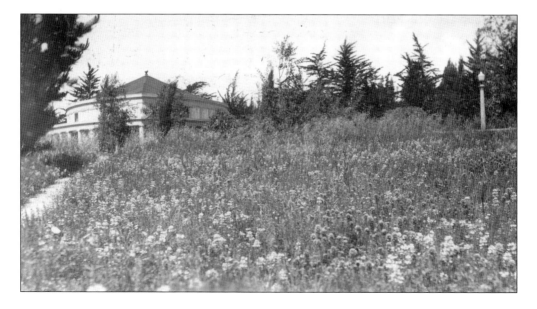

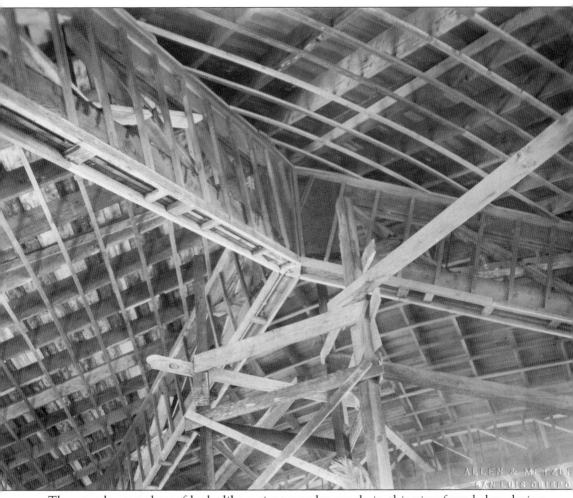

The complex temple roof looks like a giant wooden puzzle in this view from below during construction. While much of the building was erected in 1923, the roof was not completed until mid-1924 due to the triangular structure's complicated engineering.

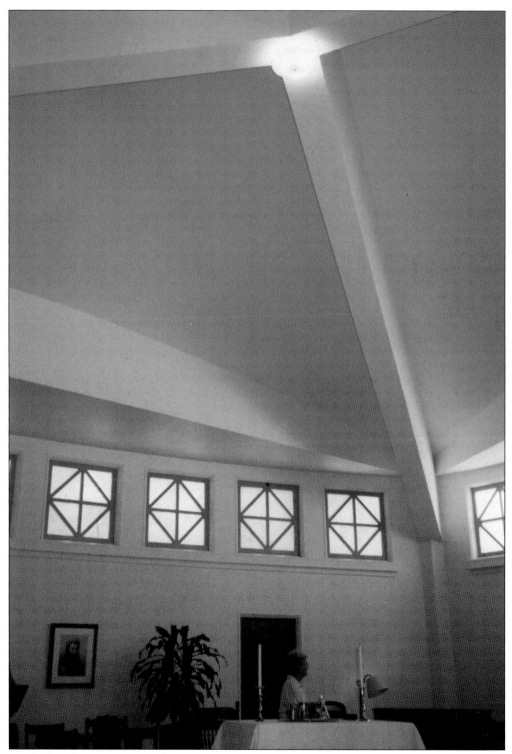

Inside the Blue Star Memorial Temple, a light glows at the apex of the completed ceiling, above the central altar. The simple lines and soft light draw the eye upwards.

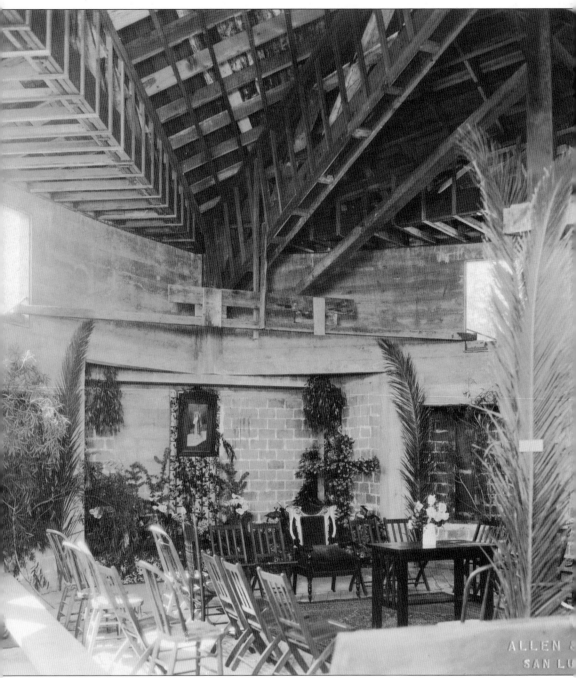

ALLEN &
SAN LU

Community members decorate the unfinished temple interior with plants and palms, making use of folding chairs and a table for an altar, as they celebrate one of the first services in the new sanctuary. The occasion, on August 3, 1924, was the annual convention, when temple members from all over the world gather in Halcyon. The temple still serves as the center of worship for the community.

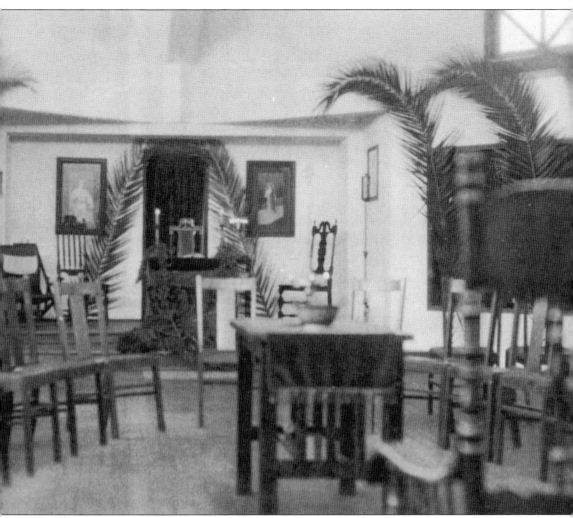

Palm fronds decorate the temple in the late 1920s for the August convention. At left is the folding leather traveling chair used by Helena P. Blavatsky, founder of the Theosophical Society. The chair was presented to the Temple of the People by her friend, Countess Constance Wachtmeister.

THE TEMPLE OF THE PEOPLE HALCYON CALIFORNIA

Through the years, artists and photographers have created images of the Blue Star Memorial Temple. The sketch above was drawn by Harold Forgostein, artist and temple leader. The drawing below appeared in the April-May 1923 issue of *Temple Artisan* magazine. Temple leader Dr. Dower explained, "It is very difficult to make any drawing that would convey a correct idea. . . . When the building is completed photographs will give a better concept."

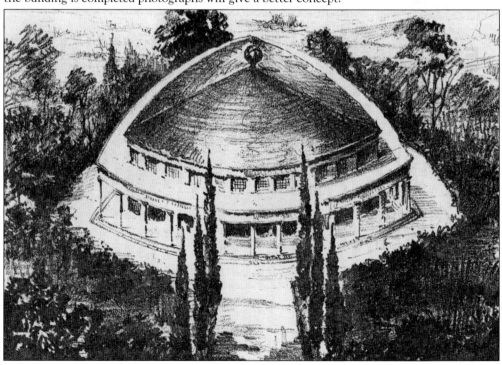

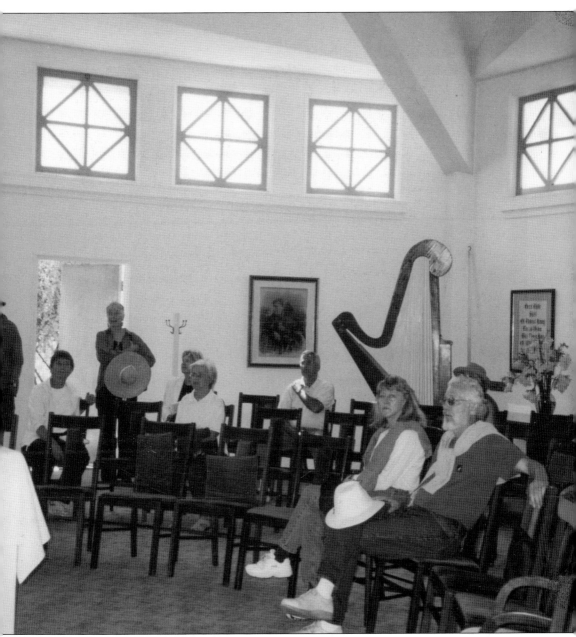

People gather for a service in the Blue Star Memorial Temple. The harp in the background was hand-built in Halcyon by early member John Varian. Varian constructed several harps during his lifetime.

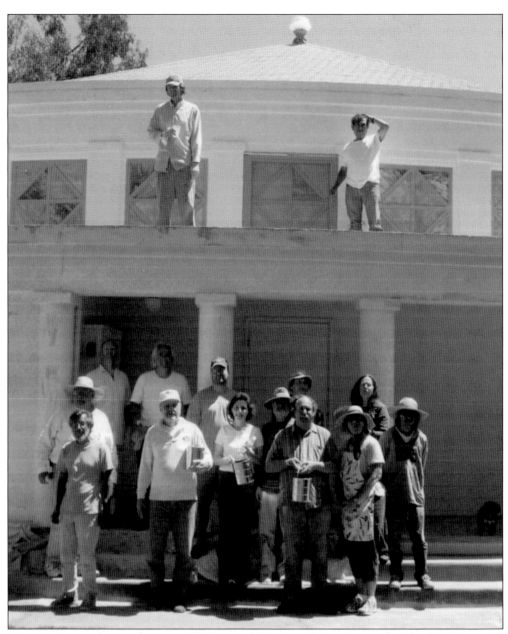

Community members work to put a fresh coat of gleaming white paint on the Blue Star Memorial Temple. For any building approaching its 100th birthday, maintenance is ongoing, and Halcyon residents gather regularly to clean and polish the temple. It could be said that the community showers it with love. From left to right are (first row) Alfredo Arciniaga, Don Forth, Rita Moiseyeva, Istvan Balogh, David Brkovich, and Lu Taylor; (second row) Chris Thyrring, Will Dunbar, George Colendich, Damian Rollison, Marti Fast, Debra Rowlands, and Frank Zuniga. Standing on the roof are James Allen (left) and Aureliano Rodriguez.

Four

HISTORIC BUILDINGS
THEN AND NOW

The pioneer temple members were faced with physically creating the community of Halcyon, building by building. Their first endeavor was construction of the Headquarters Cottage, which remained in use from 1903 until it was demolished and replaced in the late 1950s.

The Open Gate was dedicated as a healing center for the relief and cure of consumption. Built in January 1906, the large, square redwood structure was flanked by wooden-floored, tent-topped cottages erected on the grounds for patients. It serves today as a private residence and guesthouse.

The Halcyon Store opened in 1908 to provide goods and sundries for the community and included space for a second-class US post office. The structure was moved a half-block south in 1947 to its present location, where locals still pick up their mail, visit, and browse its wares.

The Hiawatha Lodge was built as a community center for the village in 1927. With a simple design that makes for a versatile gathering place, the assembly room can hold rows of chairs to face a traditional proscenium stage or be arranged with tables and chairs for community potlucks. The warm tufa-stone fireplace invites cozy chats in the main room, while a multiuse area in back includes an ample working kitchen and space for projects.

The William Quan Judge Library was originally constructed as a guesthouse in the spring of 1932 with 16 rooms on two floors. Its use changed in 1956, when the Halcyon Library collection was moved to the first floor and temple offices were relocated upstairs.

Intended as a place for art and learning, the tall, single-story building called the University Center was built in 1971 to host decades of lectures, art and historical exhibits, concerts, and study classes.

One of the most important buildings in the community's history is the Victorian mansion known as the Halcyon Hotel and Sanatorium, where Dr. William H. Dower established his medical practice. Owned by the temple from 1904 to 1947, it is located a few blocks from the Halcyon Historical District boundary on Highway 1.

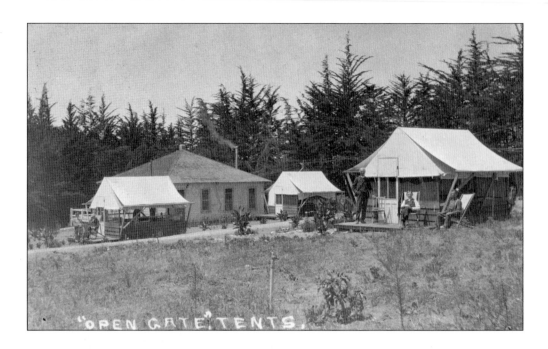

Lovingly named the Open Gate, this early California structure was constructed by the temple in 1906 as headquarters for the relief of consumption (tuberculosis). Wooden floored, tent-topped cottages were erected on the grounds for patients. Meals and treatments were given inside the building itself, in the left background above. Electricity came to the Open Gate from a power station set up in Arroyo Grande in 1906.

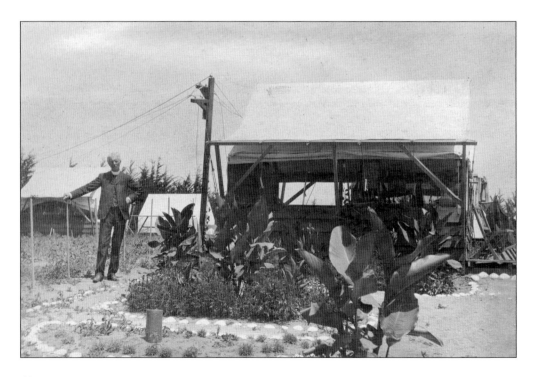

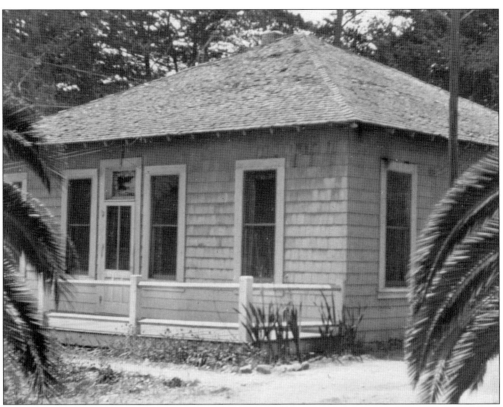

The functional form of the one-story Open Gate building shows the simple construction used just after the turn of the 20th century. Lumber, the primary early construction material for the area, was used for this wood-framed building with its hipped roof. The building now serves as a private home and a guesthouse for the temple.

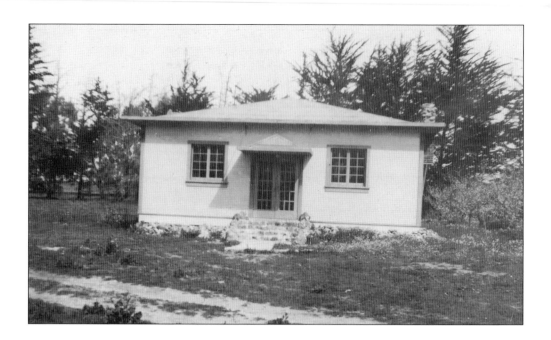

The Hiawatha Lodge, simple in design, was constructed in the spring of 1927 as the community center for the village. It has been used for many purposes through the years and has a large assembly room with a stage, a stone fireplace, and a multipurpose kitchen. The picture above shows the lodge soon after construction. The chimney for a stove shown on the east wall of the building was later replaced by a large tufa-stone fireplace on the west. Temple Street, the grooved sand track above, was eventually paved.

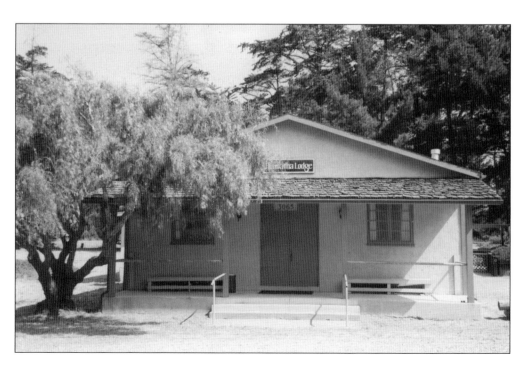

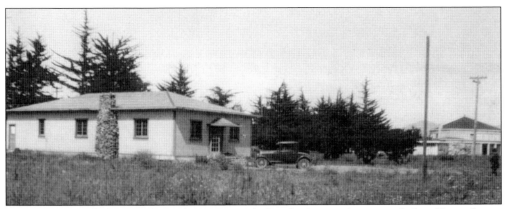

Rustic, single-walled Hiawatha Lodge was named after the famous American Indian Hiawatha, to commemorate the efforts of the temple founders. Both Dr. Dower and Francia LaDue worked for American Indian rights in New York State and were welcomed there as members of the Onandaga tribe before moving to California to establish Halcyon.

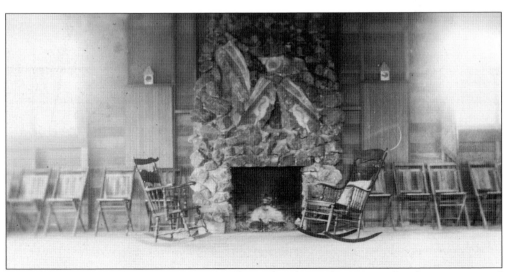

The interior of the Craftsman-style Hiawatha Lodge shows the massive fireplace constructed of the unique golden-hued tufa stone that came from a local quarry. The main assembly room features an open-beamed ceiling. The exterior is finished with custom-milled horizontal redwood lap siding.

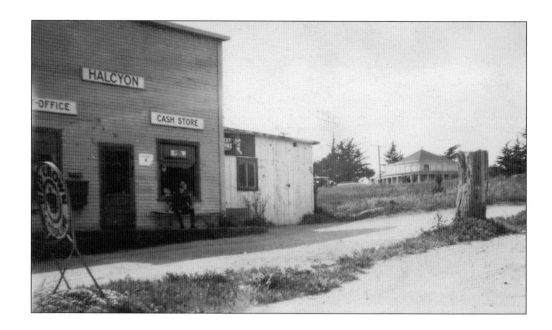

The Halcyon Store and Post Office was established in response to a request made by the temple to the general post office department in Washington, DC. The application for a second-class post office under the name of Halcyon was granted around August 1908. A small building for the enterprise was erected along Halcyon Road.

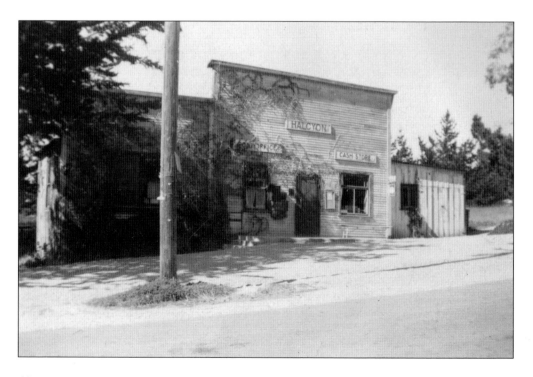

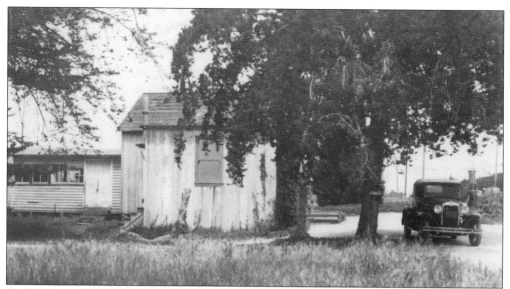

A vehicle is parked in front of the Halcyon Store, blocking the view of the roadside gas pump. At left is the Halcyon Print Shop building attached to the store. These structures were later salvaged and used to build the new store a half block south.

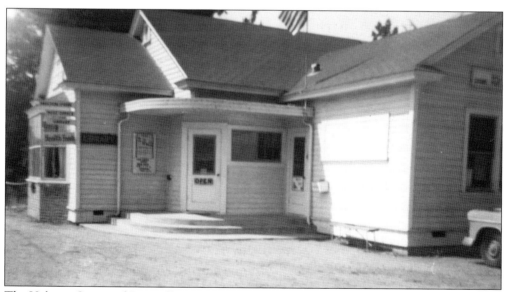

The Halcyon Store and Post Office is shown as it appeared in 1960. The rambling, vine-covered wooden building first used had become quite decrepit. Rather than undertaking a complete remodel, parts of the original that were salvageable were moved down the hill to the southwest corner of Halcyon Road and LaDue Street in 1947. This wood, along with lumber salvaged from the former pottery works, was used to frame the new building.

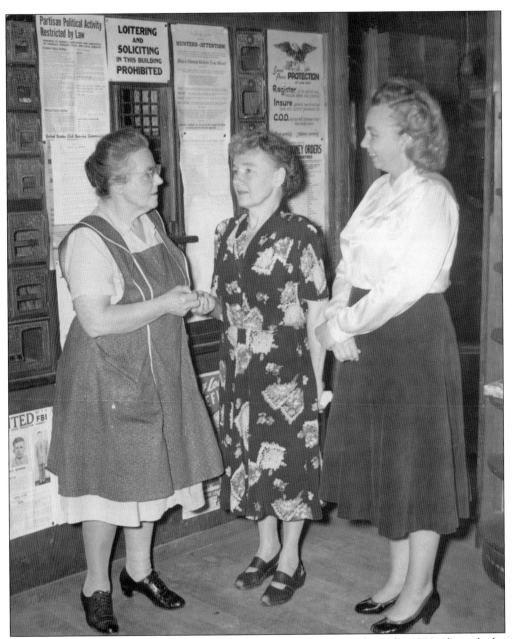

The three people who everybody in the Halcyon community knew from the 1930s through the 1960s are shown in this picture inside the Halcyon Store and Post Office, which also housed the county branch library. Aileen Harrison (left), the longtime postmistress, hands her keys to her successor, Joyce Hedin (center), as librarian Louise Lentz watches.

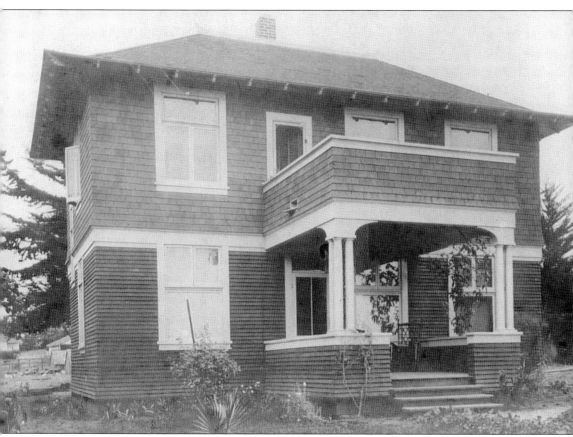

Francia LaDue's home was built in 1903 near the junction of Halcyon Road and LaDue Street. The first building constructed in Halcyon, it served as headquarters for the temple and housed the community's first library. It was demolished in 1957.

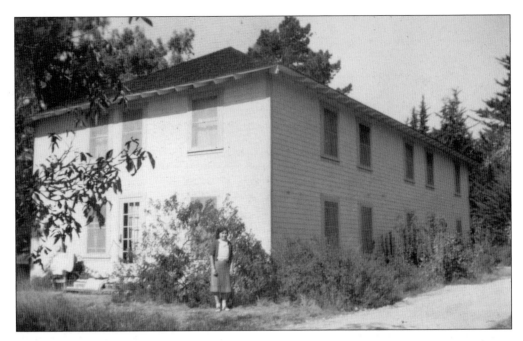

The William Quan Judge Library building was originally constructed as a two-story guesthouse in 1931–1932. The design of the building was simple, with 16 rooms and a bathroom with hot and cold running water on each floor. Funding and labor for the building came from donations. Temple member Louise Ferguson is shown in front of the building above. The building's use changed when several single rooms on the first floor were remodeled for the library in 1956. A front door and small entry porch were added facing Halcyon Road (below). A second remodeling in the early 1970s converted other rooms to a guest suite and offices.

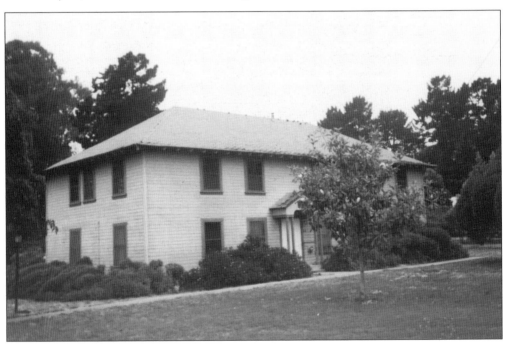

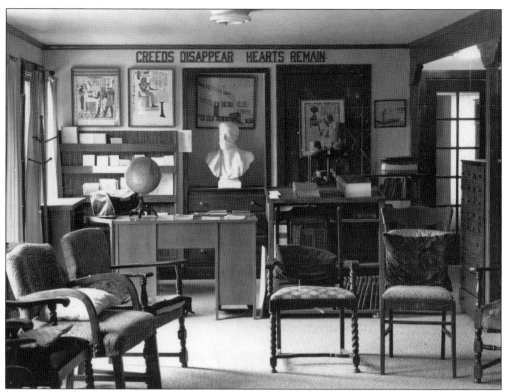

The William Quan Judge Library houses approximately 15,000 volumes and has welcomed many researchers to access its major collection of books on theosophy and philosophy. The plaster bust of namesake William Quan Judge appears to be watching over library activities. Judge was cofounder and president of the American section of the Theosophical Society from 1875 to 1896.

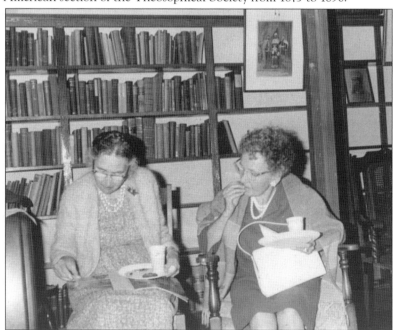

Two members of the temple admire new books during an afternoon tea in the Judge Library in August 1958. Gertrude Tedford (left) and Joyce Hedin are shown comparing notes during the function. The library is often used for small social events.

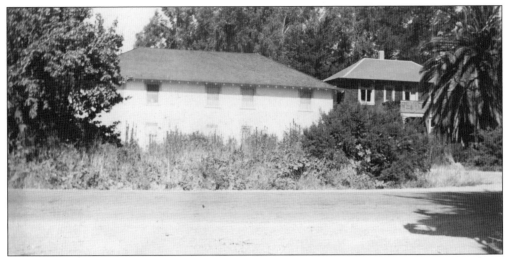

Looking west across Halcyon Road, the William Quan Judge Library is shown prior to remodeling, along with the first home built in Halcyon. This home was constructed for leader Francia LaDue and was replaced in the late 1950s.

The Central Home was constructed next to Judge Library in 1960. This new home for the temple guardians replaced the old two-story headquarters building. Pearl Dower, the third guardian in chief, stands in the front doorway prior to landscaping.

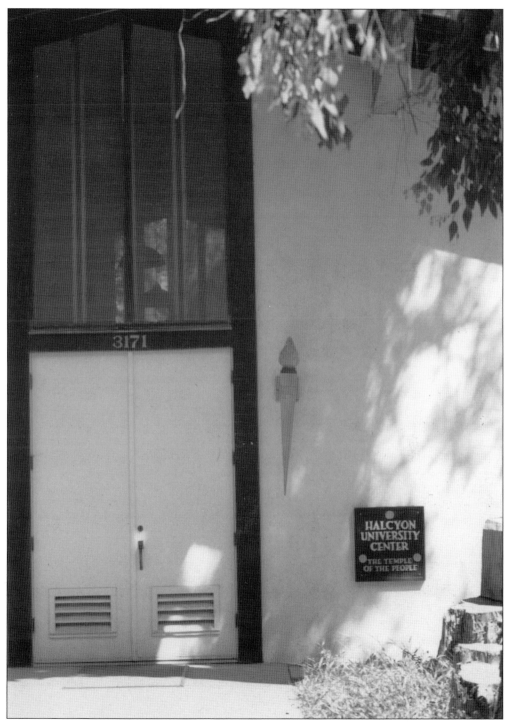

The Halcyon University Center is a tall single-story building constructed in 1971. Newer in character, the 1,600-square-foot building has no lower windows, creating ample exhibit space and room for lectures, concerts, receptions, and study classes. At center is one of the two torch-like lights that flank the front doors, designed and fabricated by local artisan Pat Fitzgerald.

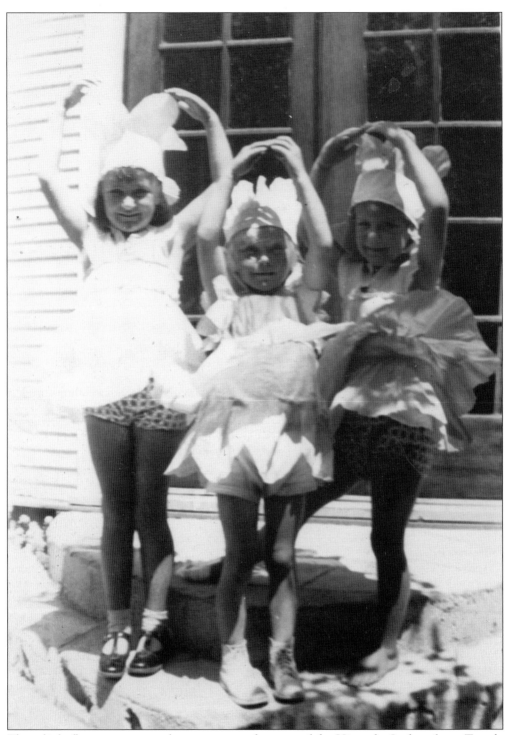

Three little flowers recreate a dance move on the steps of the Hiawatha Lodge after a Temple Builders play in the early 1940s. They are, from left to right, Roselma Shumway Quinn, Mona Lee Schussman Kelly, and Karen White.

Five

ARTISTS AND INVENTORS

Nurturing creativity has always been a key component of life in Halcyon. Artists, poets, equestrians, engineers, musicians, writers, and philosophers have credited the soil and soul of Halcyon with influencing their work.

One of the earliest members of the temple was John Varian, the Irish poet who wrote *The Building of Bamba*, a pageant-like play with music by Henry Cowell. Varian's sons, Russell and Sigurd, became inventors and engineers, and along with neighbor George Russell Harrison, the trio profoundly influenced the disciplines of electronics, engineering, and physics. While in Halcyon, the Varian brothers invented the klystron tube, which was pivotal in the development of radar, and in 1948, they founded Varian Associates, the first company in Stanford Industrial Park.

John Varian's granddaughter Sheila Varian rode her first horse through Halcyon fields and went on to become a world-renowned owner, trainer, and breeder of Arabians.

Alexander William Robertson arrived in 1909, establishing the Halcyon Pottery Works and serving as its director and instructor. His simple bisque-firing technique enhanced the fine grain of the local red fireclay as well as the details of the relief work. The pottery closed in 1913, but surviving pieces of Halcyon pottery are prized by museums and collectors worldwide.

American composer and pianist Henry Cowell benefitted from many influences, but none was greater than his collaborative friendship with John Varian and the town of Halcyon. As a young man of 20, he wrote his most famous work, "The Tides of Manaunaun," in 1917. Cowell also looked up to Dane Rudhyar, another frequent Halcyon visitor who was an early theosophist, author, artist, astrologer, and modernist composer.

Ella Thorp Ellis, a celebrated author of young adult novels, spent part of her childhood in and around the Halcyon community and maintained her ties there until her death in 2013.

Harold Forgostein, the fourth guardian in chief, was a visual artist widely known for his exquisite watercolors of the Oceano dunes as well as a series of large oils commissioned by Dr. Dower depicting the legends of Hiawatha.

Halcyon continues to provide a rich influence in which creative spirits thrive.

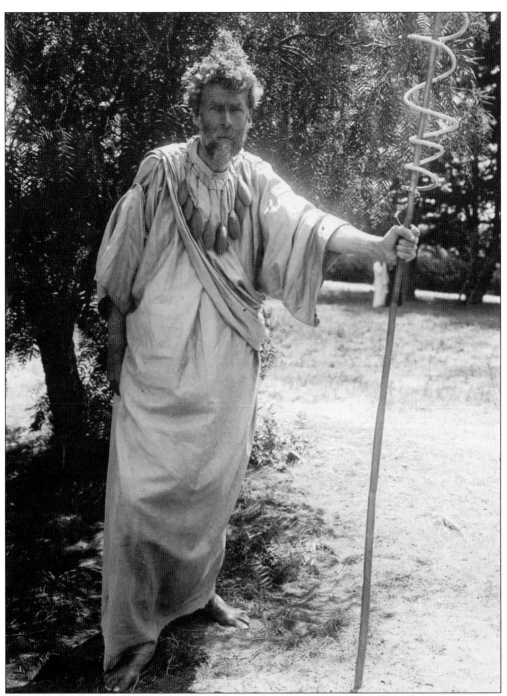

John Varian is shown as the character Oma, "God of Imagination," for the mystery play/pageant *The Harp of Life*, which he authored for presentation in August 1916. Staged at night in the garden of the Halcyon Sanatorium, it featured music, electric lighting, and a cauldron of fire. This play is linked to his larger work, *The Building of Bamba*, from 1917. The first portion of the combined works, *The Cauldron of the Gods*, was presented in Halcyon in 1914. All are based on ancient Celtic mythology.

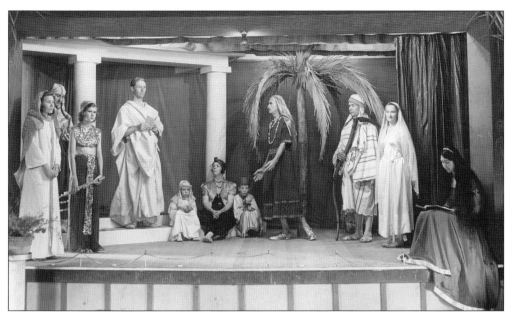

The Hiawatha Lodge was the setting for this dramatization of *The Prophet* in the early 1930s. From left to right are Jean Tedford, Bernard Lentz, Joy Thompson, Cethil Mallory, unidentified, Jane Thompson, unidentified, Duncan Ferguson, Fred Wolff, unidentified, and Gertrude Tedford.

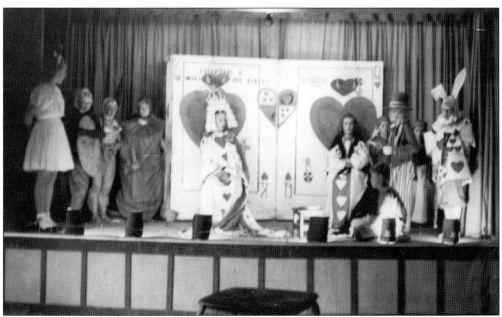

The children of Halcyon, directed by Lottie Ferguson, present *Alice in Wonderland* in 1948 and 1949 in front of the footlights of the Hiawatha Lodge stage. The original script was crafted by temple member Joyce Hedin. From left to right are (first row) Eleanor Shumway as Alice, Elizabeth Wheeler Kayadu as the Mock Turtle, Roland Mallory as the Knave of Hearts, Karen White as the Caterpillar, David Mallory as the King of Hearts, Roselma Shumway Quinn as the Queen of Hearts, Mona Lee Schussman Kelly as the Mad Hatter, and Gloria Shumway Quale as the White Rabbit; (second row) pages Bradford Wheeler and Robert Shumway.

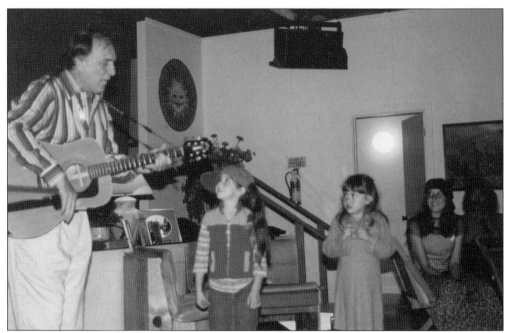

Ivan Robert Ulz (right), children's folk singer and temple member, entertains during a program in the Hiawatha Lodge. Listening are Anna Moiseyeva (center) and Zoe Rollison. Ulz was born in 1944 in Los Angeles and began writing music lyrics while in high school. He wrote, worked, and sang in Southern California and lived part-time in Halcyon. In 1980, he moved to New York, where he created music programs for nursery schools. By 2012, he had moved back to Halcyon, where he lived until his death in October 2017.

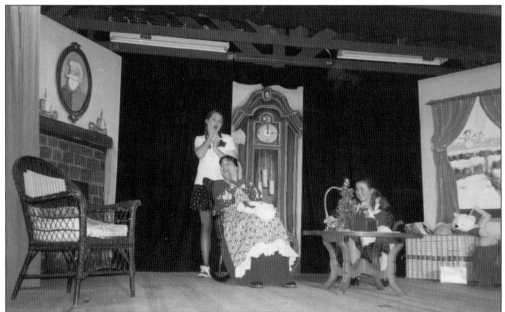

Halcyon children and their friends enjoy their first theatrical experiences on the Hiawatha Lodge stage. In preparation for the show, they create props, build costumes, and paint sets. From left to right are Mindee Thyrring, Kaety Rollison Jensen, and Kristel Thyrring.

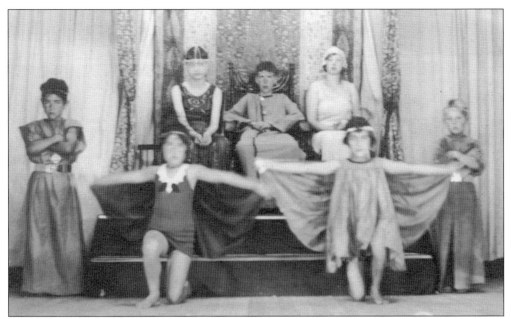

Seven unidentified members of the Temple Builders youth group present songs, dances, and recitations in August 1932 on the stage of the Hiawatha Lodge. The two on the outside appear to be guarding the dancers in the front, and royalty is seated on thrones in the back. The *Temple Artisan* magazine from that time stated, "At half-past twelve the Temple Builders served luncheon to the guests and entertained with songs, dances and recitations. They had a great time, and so did we."

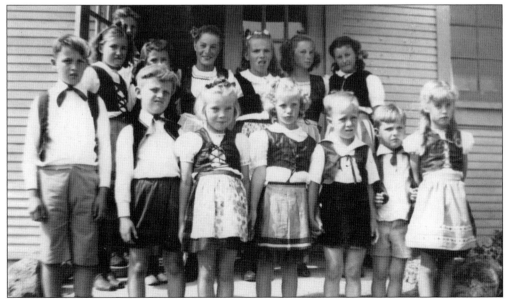

Dressed as Swedish folk dancers, members of the Temple Builders children's group pose on the front steps of the Hiawatha Lodge after a performance during the August 1944 convention. From left to right are (first row) David Mallory, Roland Mallory, Gloria Shumway Quale, Karen White, Seth Wingate, Paul Wingate, and Sheila Varian; (second row) Roselma Shumway Quinn, Ella Thorp, Katherine Gerber Hume, Eleanor Shumway, Leslie Gerber Benn, and unidentified.

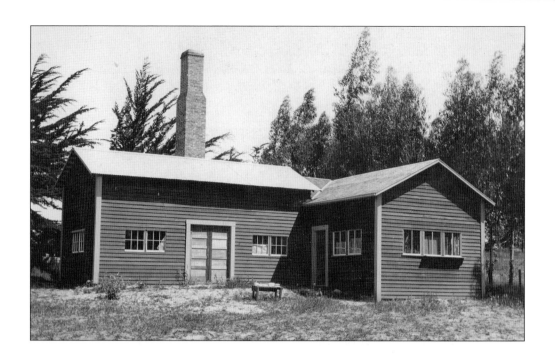

The Halcyon Pottery Works was established in 1909 to advance production and distribution of useful craft items. Alexander W. Robertson, from the Bay Area's Roblin Art Pottery (1898–1906), became the director, and firing began in 1910 using locally sourced material. The pottery closed in 1913, then reopened between 1929 and 1931 with Gertrude Rupel Wall of Walrich Potteries of Berkeley, California, teaching classes. The two-kiln pottery building (above) no longer exists. The local clay produced a red ware that was adorned with molded, raised decorations. Examples of these works, exemplary of the rise of California arts and crafts, are shown below.

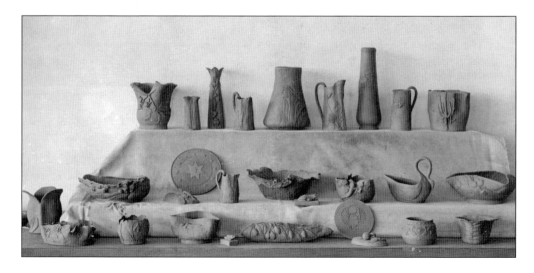

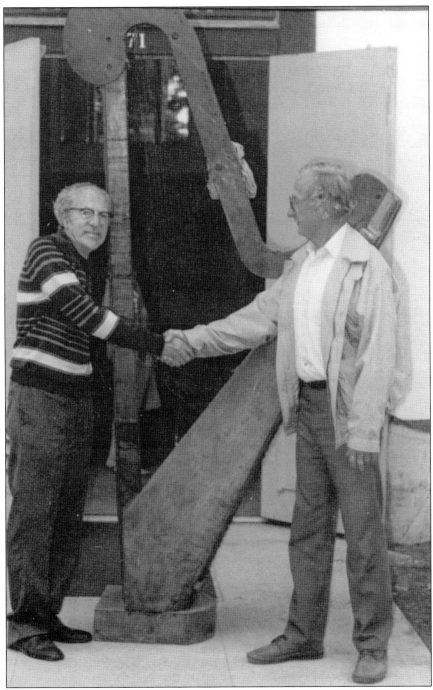

An Irish harp built by temple member John Varian in the early part of the 20th century is returned to the Temple of the People in 1987. After Varian's death in 1931, the harp was stored in a garage, and later given to the Loomis Historic Ranch, where artifacts from the Arroyo Grande Valley were displayed. Gordon Bennett (right), representing the Loomis family, is shown bringing the harp back to Halcyon. Welcoming him is Harold Forgostein, the fourth guardian in chief. The restored harp is now in the Blue Star Memorial Temple, where it serves as a symbol of the soul of music.

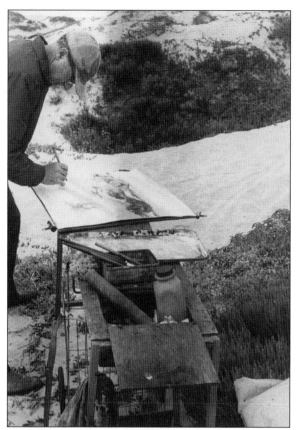

Harold Forgostein, the fourth guardian in chief, was recognized as a highly talented artist and teacher. He graduated from the Carnegie Institute of Technology with a bachelor of arts degree in painting in 1927. He joined the Temple of the People while working in New York City, where he began a series of large oil paintings depicting the life of Hiawatha at the request of temple founder Dr. Dower. These 22 large canvases, completed after Forgostein moved to Halcyon in 1941, are part of the temple's permanent collection. He also began to paint watercolors of the dunes, a subject that fascinated him and led to a collection of more than 800 works. Forgostein (left) is shown painting en plein air in the Oceano dunes. Below are, from left to right, Forgostein, Eleanor Shumway, and Marti Fast discussing details for a major showing of his works.

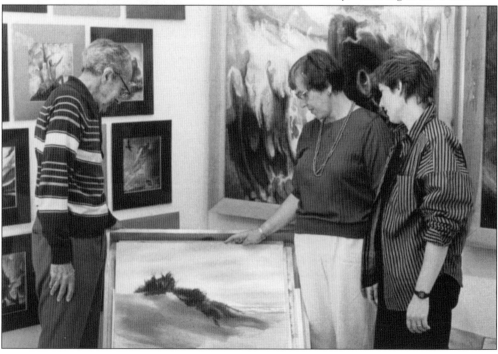

Author Ella Young came to California from Ireland and often stayed with the Varian family in Halcyon. On an extended visit in 1928 and 1929, she wrote her children's book of Irish legends, *The Tangle-Coated Horse*, for which she won the prestigious Newbery Medal. She lectured in Irish mythology at the University of California at Berkeley and was involved with the Dunites at Oceano Beach. She later settled in nearby Oceano and was active in Halcyon activities.

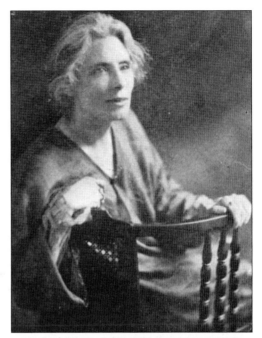

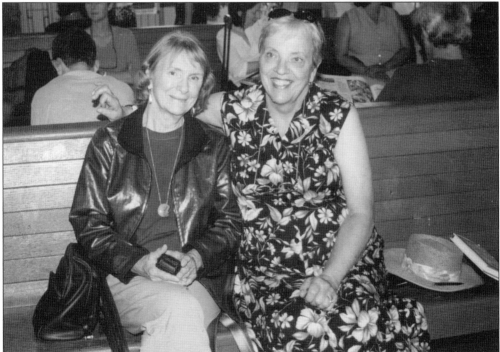

Ella Thorp Ellis (left), shown with childhood friend Eleanor Shumway, grew up as the only child in the Dunite Colony, a bohemian community in the Oceano dunes. She made many childhood friends in Halcyon before moving on to a more traditional life. She has been celebrated for her young adult novels, six of which were American Library Honor Books of the Year. She was also a lecturer at San Francisco State University. Her last book, *Dune Child*, written in 2011, is the story of her life in the local area.

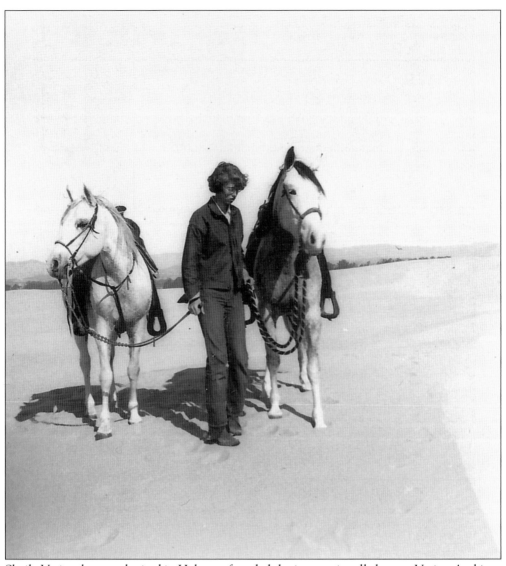

Sheila Varian, born and raised in Halcyon, founded the internationally known Varian Arabians while still living in the community. She was among several Halcyon children who started with backyard horses—her first purebred Arabians were corralled behind her family home. The operation became so successful that it expanded to rural Arroyo Grande. Sheila is shown walking on the beach around 1955 with Farlotta (right) and Jerry.

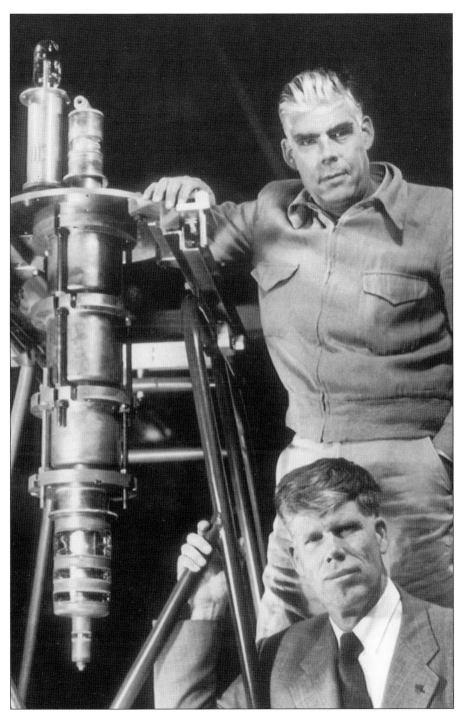

Russell Varian (below) and his brother Sigurd Varian are shown in 1956 with their klystron tube. The word "klystron" stems from Greek, meaning the bunching of waves on a beach. Their early research was conducted at the Sigurd Varian home in Halcyon and led to the formation of the Silicon Valley companies now known as Varian Inc., and Varian Medical Systems Inc. This early photograph was taken by famed photographer and Varian family friend Ansel Adams. (Courtesy of Varian Inc.)

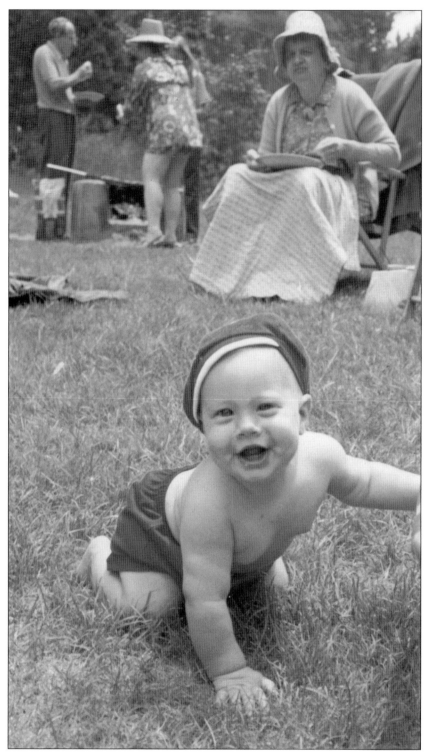

A bright sunny day brings the community out for a picnic. One-year-old Damian Rollison puts on a happy face as he wanders freely through the Halcyon grass at this summertime gathering in 1970.

Six

COMMUNITY LIFE

The art of living together in an intentional colony can be as challenging as it is rewarding. The original templars believed that unified effort and the Golden Rule were essential to Halcyon's success, a conviction that has sustained the community through periods of war, the Depression, storms, death, and other change. In this place where individuals agree to live and work together as consciously as possible, the community fabric has been reinforced through decades of shared meals, temple events, community workdays, and creative endeavors that contribute to a stable, nurturing environment. The proverb "It takes a village" holds extra meaning for Halcyonites in all areas of community life.

In this place, children are both adored and gently supervised by the adults. As a Halcyon-born octogenarian puts it, "Halcyon has always been a great place for children, cats, dogs, and even chickens. It is all about the freedom to climb a tree, yell out loud, roam around the neighborhood, and roll in the dirt, knowing all the while that the whole community is there to support you."

Halcyonites pitch in for occasional workdays by tending community spaces, prepping for fresh paint, or clearing brush from trees and gardens. Social gatherings, equally important to a healthy life, offer companionship and connection at holiday celebrations, yoga classes, bridge games, fireside singalongs, and bountiful potlucks for residents and friends.

Creative and dramatic traditions began on the grounds of the Halcyon Hotel and Sanatorium, where locals walked or rode horseback from all over the Arroyo Grande Valley to witness the lavish outdoor plays and musical productions put on by the Halcyon group. Since 1927, skits, plays, and musical revues have been produced at the Hiawatha Lodge in community collaborations where volunteers paint scenery, create costumes, write scripts, direct, and perform in the shows.

At the heart of Halcyon is the temple, where the daily noon meditation, Sunday services, and study classes enrich life with meaning, tradition, and vitality in this historic place.

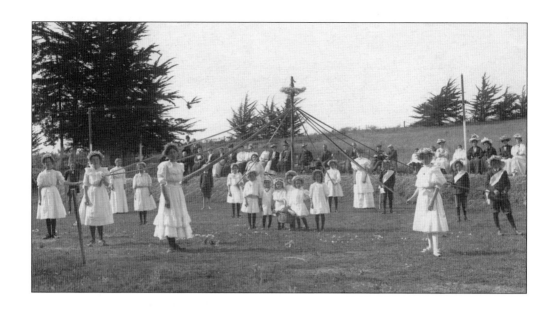

May Day is celebrated with music, dance, flowers, and the traditional Maypole during an event at the Halcyon Sanatorium in the mid-1900s. Spectators are seen (above) watching the festivities from the nearby hillside. The older children are seen dancing (below), while six little ones pose with a basket of flowers.

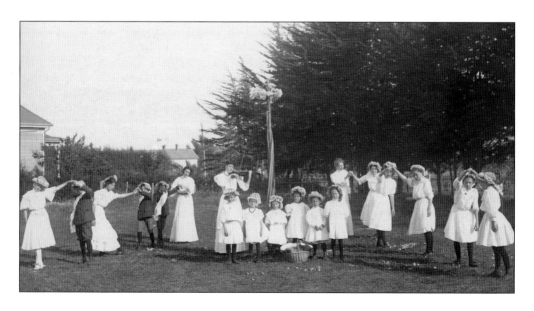

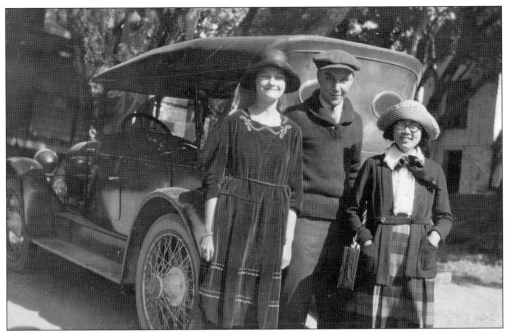

Lifelong Temple member Herman Volz (center) poses with his sister Nora (left) and their friend
? Wong. Handwriting on the back of the 1923 photograph says that the trio were visiting the
"San Louis Hot Springs."

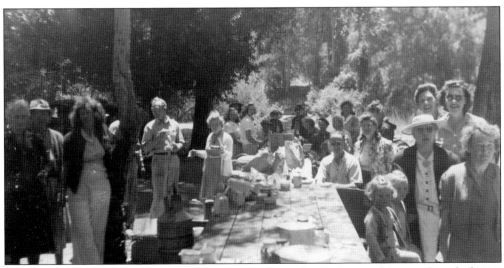

Temple members and friends gather for a picnic at Routzahn Park east of Arroyo Grande during
a convention in the late 1940s. The park, in a deep canyon at the headwaters of the Arroyo
Grande Creek, was a popular gathering spot until it was flooded after construction of the Lopez
Dam in 1968.

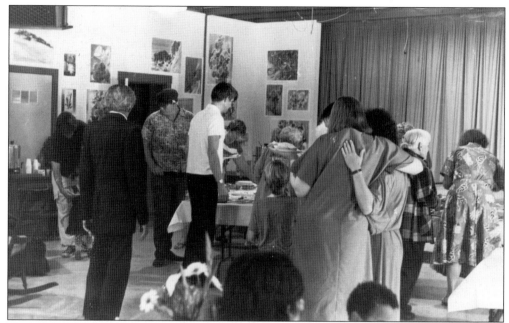

The community gathers in the Hiawatha Lodge for a potluck luncheon at one of the periodic art shows and sales. Featured are unframed watercolors by Guardian in Chief Harold Forgostein, who often donated his paintings to raise money for temple projects. His works hang in many Halcyon homes as well as many throughout San Luis Obispo County and beyond.

The Hiawatha Lodge is dressed for a potluck in this picture featuring the historic folding chairs that served the community from 1927 to the end of the 20th century. The chairs were sold as antiques after a failure that placed one temple member on the polished floor. Many residents of the community shared the experience of opening, setting up, sitting on, taking down, and storing these chairs.

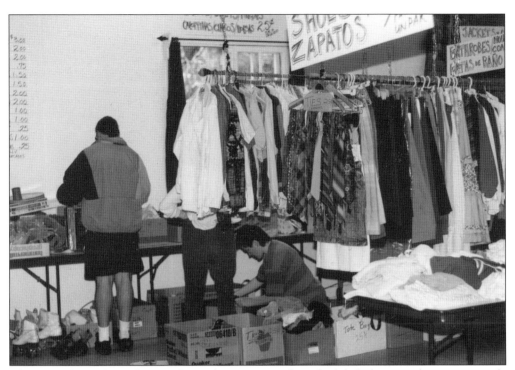

The Hiawatha Lodge is the site of periodic rummage sales, scheduled whenever the urge to recycle strikes the community. Large crowds gather for the eagerly awaited event.

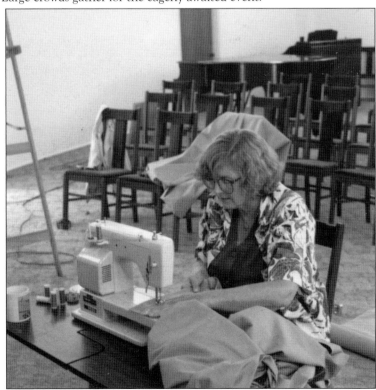

Barbara Norman moves her sewing machine to the middle of the action while constructing new drapes for the Blue Star Memorial Temple during a major interior renovation. As a member of the congregation, she volunteers her services during such events and serves as executive secretary in the temple office.

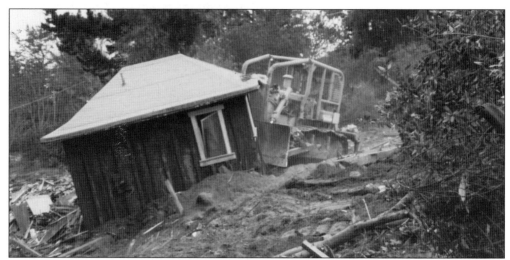

Renovation of Halcyon homes takes many forms. Sometimes, people use paintbrushes and hammers, but in this case, Halcyon resident and temple member Gene Clark uses a bulldozer to clear the site for a new home. The old home, built in the early 1900s, could not be saved. Useful materials from the home were removed prior to demolition.

When anything had to be done around Halcyon, Herman Volz volunteered. Volz came with his family to Halcyon as a teenager in the 1920s and remained here for the rest of his life, with a short timeout during World War II for service in the US Army. He is shown in 1985 working on water reports in his capacity as director of the Halcyon water system. He lived in Halcyon until his death in 1986.

Maintenance is one of the challenges of retaining the appearance in a historic village where many buildings are 80 to 100 years old. Will Dunbar is shown scraping and painting the two-story, saltbox-style William Quan Judge Library and temple offices. Temple member Evelyn Elliott Carlberg designed the building, which was constructed of redwood by temple workmen in 1931–1932.

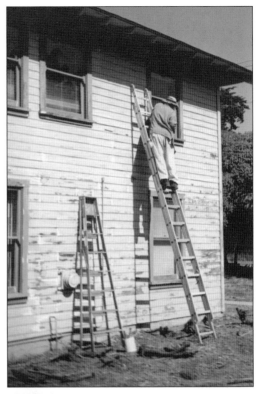

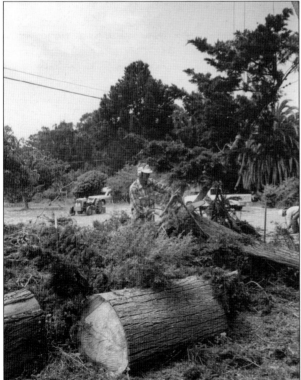

Trees grow, and trees also fall. Jerry Sabol (left) and Herb Lentz clean up a cypress that fell outside the temple office in 1994. Halcyon is recognized for its abundance of trees, which early residents planted in large numbers. Current residents continue this effort.

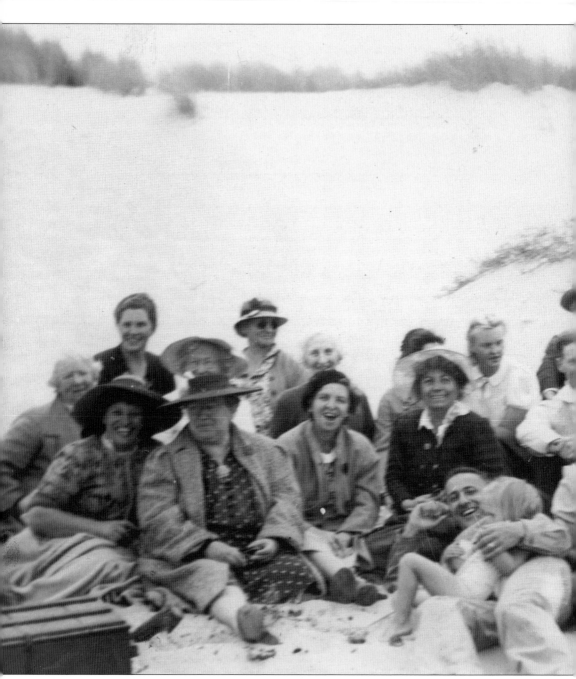

A day at Oceano Beach was a good excuse to gather for a picture in the late 1940s, before the sand dunes behind the crowd were covered with houses. Among the families gathered are Herb Lentz, lying down next to his wife, Marylouise, and their children, Patricia (left) and Susan. Sitting behind them are, from left to right, Pat Mallory, Lottie Ferguson, Gertrude Tedford, Monica Ting,

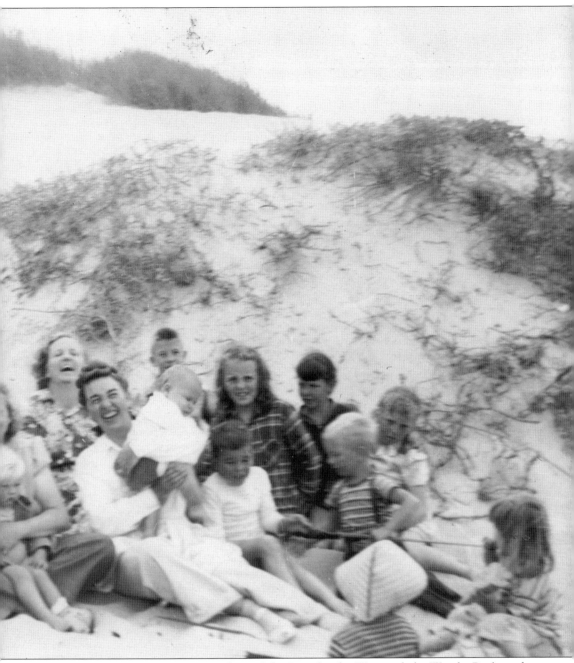

and Cethil Mallory. At right are members of the Ross family: Winnie, baby Wendy, Buck, and Gary, surrounded by other children. In the very back are, from left to right, Polly Tarbox, Roberta Shumway, Ella Vogtherr, Martha Schussman, and others who are unidentified.

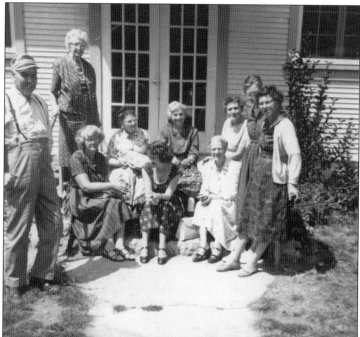

Halcyon residents enjoy lining up and posing for pictures. This happy group sits in the sunshine outside the Hiawatha Lodge in September 1960. From left to right are (first row) Herman Volz, Martha Schussman, Ruth Hoppe, Margie Cyr, and Carolyn Forgostein; (second row) Elizabeth Thomas, Flora Wheeler, Monica Ting, Roberta Shumway, and Gertrude Tedford.

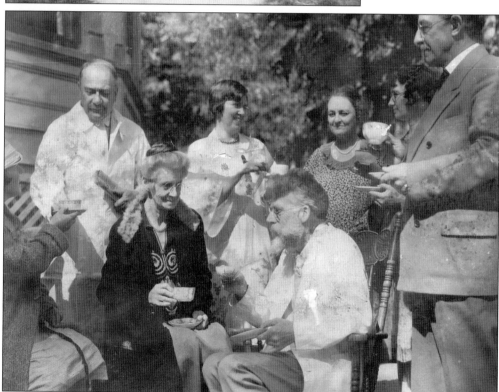

Early temple members discuss issues of the day during a tea party at the Halcyon Sanatorium. Pictured are, from left to right, Dr. Dower, Agnes Varian, Pearl Wilshire Dower, John Varian, ? Wilshire, unidentified, and Harry Harrison.

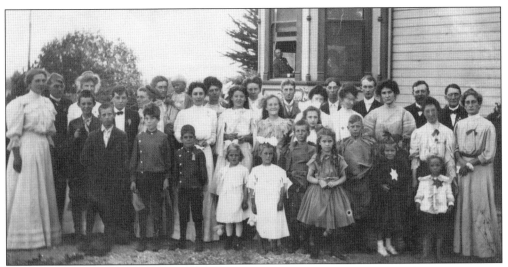

Temple Builders and their parents gather in 1908 outside the Halcyon Sanatorium. The children wear a variety of costumes, suggesting they had presented a play or pageant for the adults. The small children at right have stars pinned to their clothes, while the two boys in the center wear burlap sacks. Two lads at left are in uniforms.

Temple Builders have a problem lining up for this photograph taken outside the Hiawatha Lodge in 1942. From left to right are (first row) Robert Shumway, Gloria Shumway Quale, and Sheila Varian; (second row) Karen White, unidentified, Mona Lee Schussman Kelly, Eleanor Shumway, David Mallory, and Roland Mallory; (third row) unidentified, Joan Varian Rowlands, John Mallory, unidentified, and Michael Schussman.

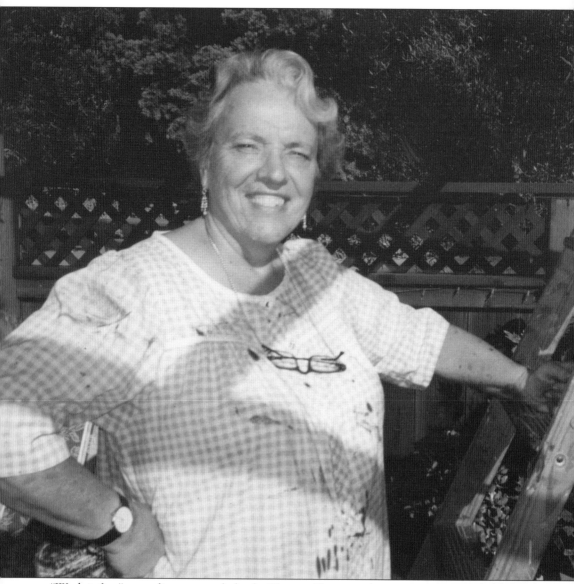

"Work is fun," according to temple leader Eleanor Shumway, leaning up against a ladder as she hangs decorations from the rafters in her patio. Known for interior and garden design skills, Shumway takes an active role in directing the maintenance of the community.

Seven

BUILDERS OF HALCYON

"That's over by Fred Wolff's house, across from the Tedford place on Helena." After more than a century, homes in historic Halcyon still carry the identities of the pioneer families who put boards together to create shelters of various types and styles.

Those early members of the Temple of the People pooled their resources to purchase the land where Halcyon sits today, but their investment in the cooperative colony did not include funding for homes. As newcomers arrived to join the community, some built modest dwellings with help from friends and neighbors, later expanding basic one- or two-room structures as they could afford. Others had the means and skills to lovingly craft bungalows with fine architectural details like hand-carved toggle door closures and custom forged strap hinges.

Aside from gravel and sand dug from the nearby Arroyo Grande Creek for concrete, building materials like cement and wood had to be imported. Many early homes were constructed of heart redwood, which likely came from the Santa Cruz area through Port San Luis. Tufa rock was hauled in from the hills east of Arroyo Grande for use in fireplaces, chimneys, porches, and walls, adding its warm golden texture to the character of village construction.

An early survey map shows the original lot layout of Halcyon in 1906, with the first homes built on land that remains in temple ownership. When a more official subdivision map of the 16-square-block village was created in 1923, lots became available for sale to members and friends. Many members who bought at this time deeded their property back to the temple. Of the 55 homes comprising the village in 2017, fourteen were privately owned, with most of those homeowners actively participating in community life and activities.

As original structures gradually and inevitably succumb to termites and age, unique restorations or replacements have been carried out in accord with the spirit of the original Halcyon builders. Such care has complemented the character of the community, allowing the history of the village to continue resonating through the walls of its homes.

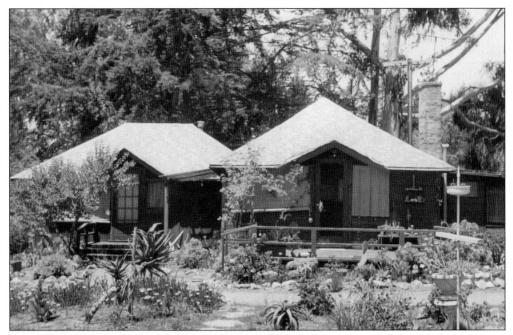

Louise Randall Awerdick came to Halcyon in 1906, after the death of her first husband. She married Leon Awerdick in Halcyon, and after his death in 1917, she became a part of the growing young community, working closely with the first guardians. She left Halcyon between 1922 and 1932 to establish her own business in Los Angeles and later took charge of a YWCA home for girls. She returned to the community, making her home in a redwood bungalow on Hiawatha Lane (above) until her death in 1959. The structure had been moved from another site in the 1920s and belonged to the temple. Awerdick surrounded it with gardens. The home was remodeled after a 1971 fire and again in 2016, and it continues to serve as a rental. At left, Awerdick admires the pool in a neighbor's yard.

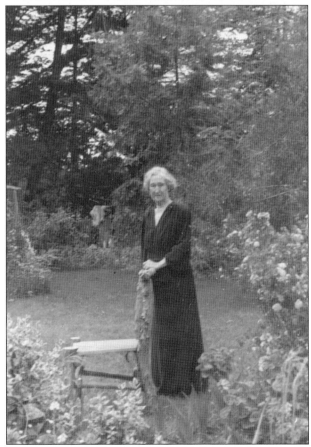

Early temple member Ellen Veblen built a small redwood cottage prior to 1922 near the Halcyon waterworks off what is now Temple Street. The bungalow was made of vertical redwood board and batten. When Veblen died in June 1926, she left her bungalow to famed composer, performer, and temple member Henry Cowell. Cowell used the home to rest between concert tours and to lend to friends. He sold it in 1932 to Emily Byrne (right), a widow who enlarged the home. Her late husband, Frank M. Byrne, had been an active settler in the Dakota territory. A member of South Dakota's first state senate in 1908, he went on to serve two elected terms as the eighth governor of the state. After an active political career, the Byrnes came west to retire. He died in 1927. Emily Byrne left her home to the temple upon her death in October 1965.

Harry Elliott, who with his wife, Mary, came to Halcyon in 1923, bounces grandson Carl Carlberg on his knee. The Elliotts purchased six lots along LaDue Street when they arrived and first constructed a small shop and garage set back from the street. Along with daughter Evelyn, they lived there while constructing a one-bedroom, one-bath redwood cottage (below). The garage was later converted into a second small home.

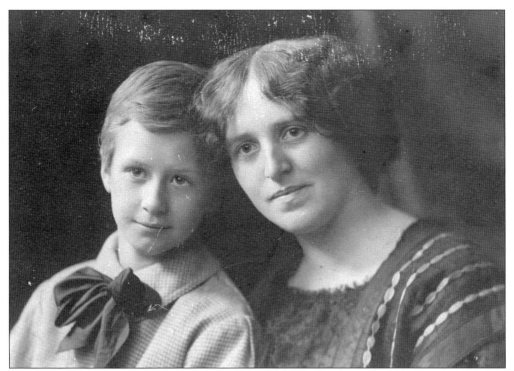

Borghild Janson, a native of Norway, came to Halcyon in the fall of 1923 to visit an old friend, Ella Vogtherr. Trained in both medicine and music, Janson became the head nurse at the Halcyon Sanatorium and organized many musical and dramatic productions. She was joined by her teenaged son Henry Carlberg in 1926, shown in an early family photograph (above) before coming to Halcyon. Carlberg later married Evelyn Elliott.

Henry, Evelyn, and son Carl Carlberg gather for a family picture in the early 1950s next to the historic family spinning wheel, which remains on display in Halcyon. The spinning wheel was built by Evelyn Elliott Carlberg's great-grandfather, Joseph L'Hommedieu, for his wife prior to 1850.

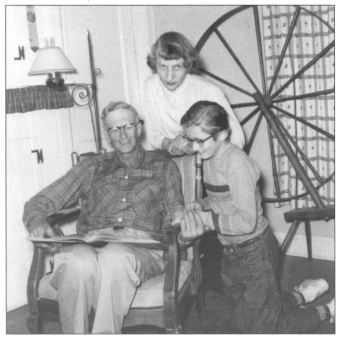

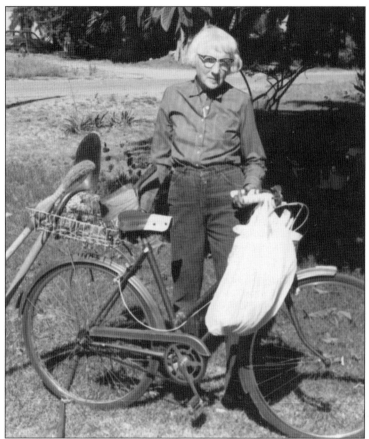

Evelyn Elliott Carlberg came to Halcyon with her parents after they joined the temple in 1923, and she made the village her home until her death in 1994. For years, Carlberg was a familiar sight as she used her trusty bicycle to travel the streets of Halcyon (left). She arrived as a teenager, married in the community, and designed and built a home for herself, her husband, and her son that still stands on LaDue Street. This European Tudor–style home (below) was built in 1939.

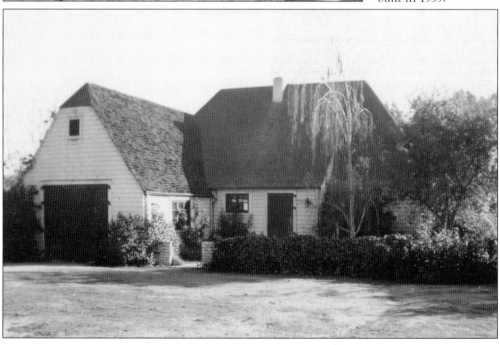

Claire Courtland arrived in Halcyon in the mid-1940s, rented a home from the temple on Dower Street, and let everyone know she was ready to teach piano. Her students came from all across the Arroyo Grande Valley to learn from this professional musician who could play Dixieland jazz and had accompanied silent movies. Courtland remained in Halcyon until her death in 1972.

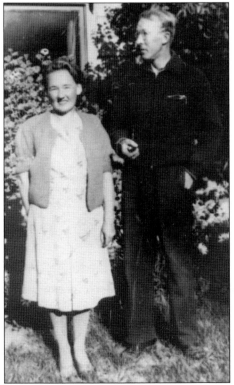

Joyce and Elmer Hedin came to Halcyon in 1934 from the intentional community of Cazadero on California's Russian River. They built a one-room cottage on Helena Street, later adding to the Craftsman-style home. Elmer was a sociologist and writer. Joyce ran the Halcyon Store and Post Office for 14 years after Elmer's death in 1955. The Hedins were one of three family groups who came from Cazadero.

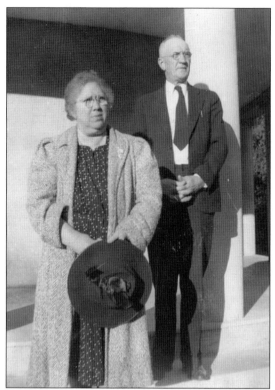

Lottie and husband Duncan Ferguson came to Halcyon in 1922 after becoming members of the Temple of the People while living in Palo Alto, California, in 1914. They originally came from Syracuse. Duncan operated a tailor shop on Branch Street in Arroyo Grande until his death in 1945. The couple was in charge of the Hiawatha Lodge for many years and supervised all the social activities.

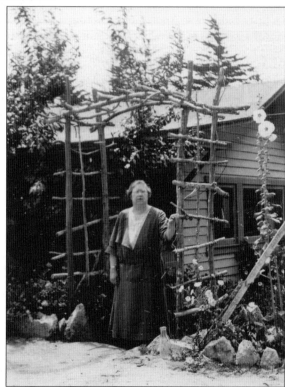

Lottie Ferguson, shown in front of her home on Dower Avenue, had a background in theater and directed plays presented in the Hiawatha Lodge. She died in 1959.

Anora Scott Gibson joined the Temple of the People in 1940 and became a frequent visitor to Halcyon, much to the delight of the children in the community. From the age of 22 in 1927, she worked as an au pair and governess for many families on the East Coast. She moved west about the time she joined the temple, working in Los Angeles as a governess. Over the years, she helped raise more than 24 children, and after retiring to Halcyon in 1975, she was always available for the youngsters.

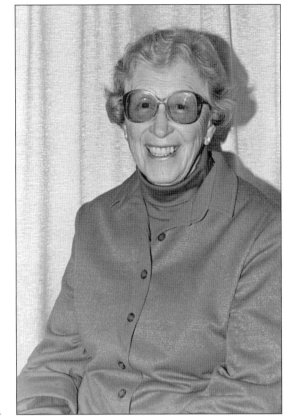

This bungalow was built as a motel unit in Pismo Beach in the 1930s and was moved to Halcyon in 1948. The wooden home has a concrete foundation and faces Ross Lane. Remodeled several times since, the home is owned by the temple and is surrounded by fruit trees. Its first resident was Anora Scott Gibson.

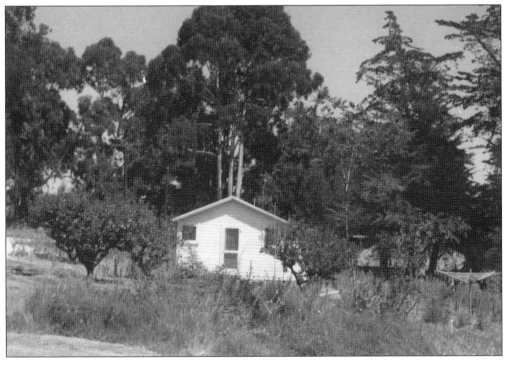

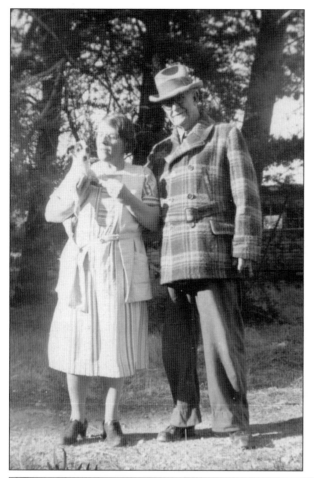

Early Halcyon residents Aileen and Harry Harrison (left) built their two-story home on LaDue Street. They framed the structure with the help of other Halcyon residents, and in a unique twist, they finished the second story first so that they could live upstairs for the year or so it took to complete the downstairs. The scene below, from the 1930s, shows the Craftsman style of the wooden structure and the extensive gardens. Harry was one of the original temple members who came from Syracuse. Aileen, who came from Australia to join her sister, Agnes Varian, ran the Halcyon Store and Post Office for many years until she retired in 1954.

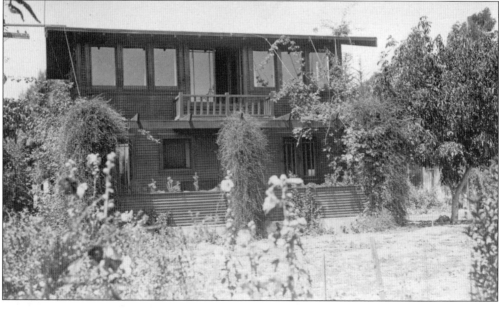

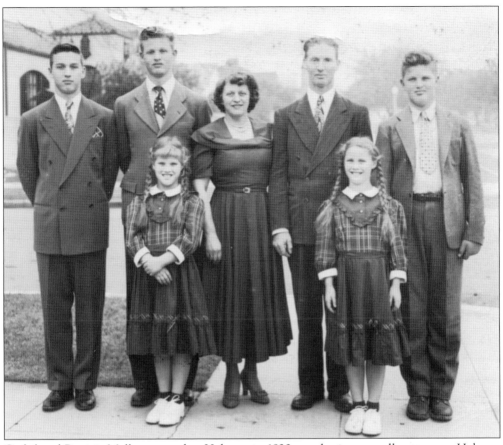

Cethil and Patricia Mallory moved to Halcyon in 1930, purchasing a small cottage on Halcyon Road that they converted to a large single-family home. All five Mallory children were born in Halcyon. Shown above are, from left to right, (first row) Cecelia Mallory Page and Diana Mallory Bennett; (second row) David Mallory, John Mallory, Patricia Mallory, Cethil Mallory, and Roland Mallory. This photograph was taken about 1949.

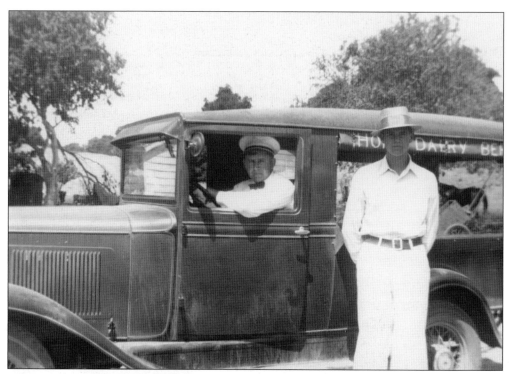

The Ross family purchased two acres of Halcyon land in 1924 to build a home and a large barn as they started the Halcyon Milk Company. They rented nearby pastureland for the herd of 60 dairy cows and supplied milk to the Arroyo Grande Valley through the 1920s. Shown above is family patriarch Lee M. Ross at the wheel of the truck with son Clifford. Younger son Bob Ross (left) is ready to deliver milk. Although the dairy operations were eventually relocated to property outside the community, the family remained in Halcyon. The barns and corral may be gone, but good memories remain on Ross Lane. The property now belongs to the temple.

Lee Ross and his wife, Frances Ross, relax in the living room of their home in Halcyon. This picture was taken about 1950, after Lee retired from the dairy business.

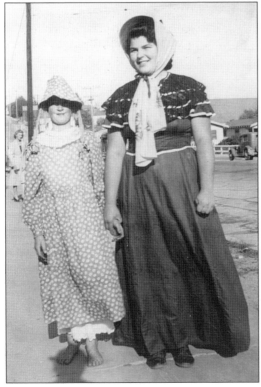

Lee and Frances Ross's daughter, Olive Ross Hoff (right), participates in an Arroyo Grande Harvest Festival parade, properly dressed for the occasion. Joining her is barefooted young Jimmy Grieb of Arroyo Grande, costumed for the festivities.

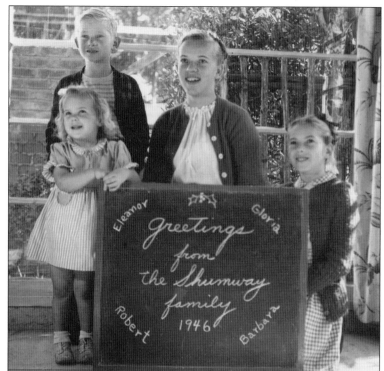

The Shumway children of Halcyon pose for a special card that was sent to friends and family celebrating Christmas 1946. From left to right are Barbara Shumway Reed, Robert Shumway, Eleanor Shumway, and Gloria Shumway Quale.

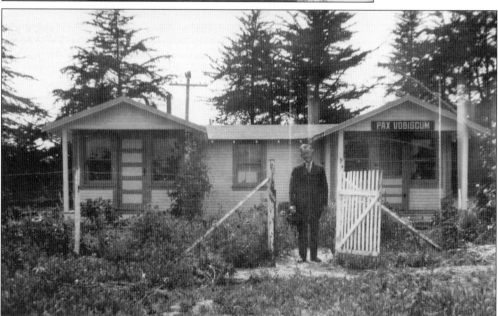

The motto on this modest home Edward Twistman built was *Pax Vobiscum*, which translates to "Peace be with you." Born in Denmark in 1862, he ran away to sea at the age of 13 and considered himself a world citizen. He told stories of his survival of the San Francisco earthquake in 1906 and authored an unpublished book about his travels, which is held in the Judge Library. Twistman joined the Temple of the People in 1919 and soon arrived in Halcyon to build his home, where he lived until his death in November 1947.

Kenneth and Roberta Shumway brought their young family to Halcyon in February 1942. He was a general contractor and builder who constructed their family home (above) on five acres off Ross Lane. The garden and patio were the sites of frequent community picnics. Kenneth and Roberta Shumway and their young son, Robert (below), are shown in 1948. After Kenneth died in 1952, Roberta taught developmentally disabled students in the local school district.

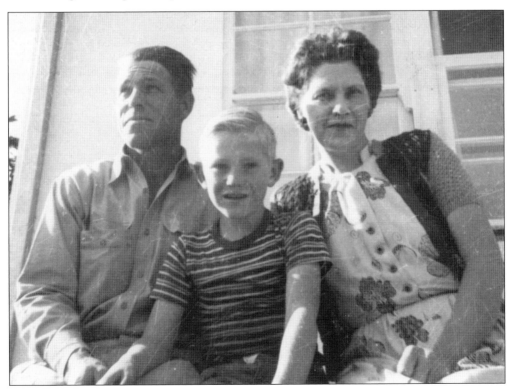

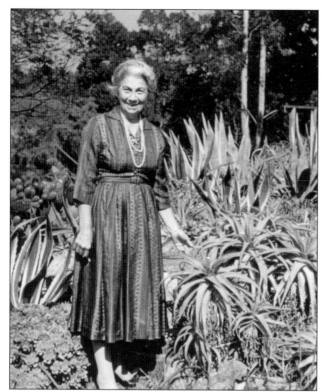

Monica Ting, a longtime member of the temple, stands in her succulent garden with prickly pear cactus and agave on Christmas Day 1953. Ting was a trained musician, singer, and composer who often provided music for events in Halcyon. She was born in Santa Monica, California, and earned degrees in music and education from the University of California at Santa Barbara. Ting joined the temple in 1919. She and her family spent summers in Halcyon, and she came to live in the community by 1942. She died in 1990.

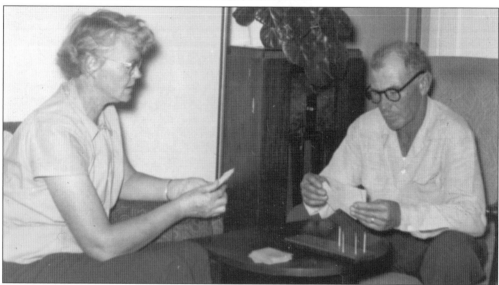

Ken and Martha Schussman, shown playing cards in their home in the early 1950s, first came to Halcyon in 1933 after residing in the Cazadero intentional community. They learned of Halcyon through their friend Wenona Tallman Varian of Halcyon. Once in the community, they purchased property next door to the Varians and moved a small cottage onto the site. They lived in Halcyon on and off during the World War II years, finally settling in the community to raise their family in 1944. In 1950, the Schussmans established Ken-Mar Gardens, first as a nursery and then as an early mobile home park, on property directly across Halcyon Road from the temple.

Isabel "Aunt Polly" Tarbox (left) and "Miss Emma" Oviatt take a walk in Halcyon in the late 1920s. Tarbox joined the temple in 1919 in Columbus, Ohio, and came west with her family. By 1921, she was living in Halcyon with her four children. The children left the community for education and careers. Tarbox remained active in temple work until her death in 1966. Oviatt, born in 1864, joined the temple in 1917 from Santa Barbara, California. Beginning in 1923, Oviatt lived in Halcyon and served as stenographer for the temple. This responsibility also involved mimeographing services for the community. Oviatt died in 1939.

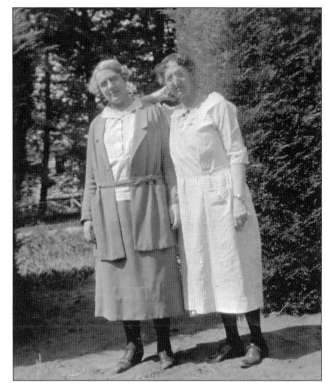

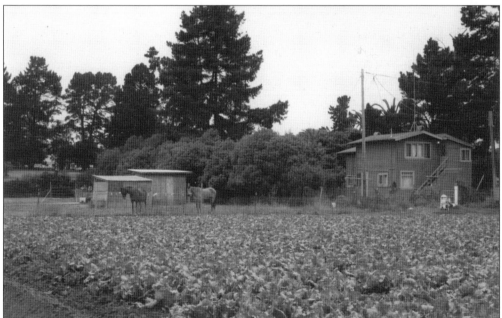

Rich farmland is a part of the Halcyon Historic District, and residents have an up-close view of a thriving vegetable field (shown here) looking northeast from the end of Hiawatha Lane. The historic Harrison home is at the right, while the sheds to the left provide shelter for two saddle horses. Growing in the foreground is young sustainably farmed broccoli. Of the 130 acres that make up the district, more than 50 acres are dedicated to agriculture.

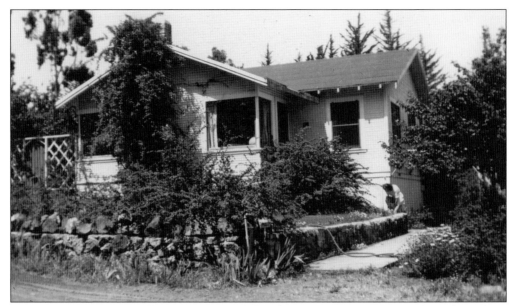

In 1934, Gertrude Tedford and her teenaged daughter Jean traveled by Greyhound bus from Boston, Massachusetts, to begin a new life in Halcyon. Within months, they started construction of a Cape Cod–style home on Helena Street (above). They were eventually joined by Gertrude Tedford's parents and two sisters, who remained in Halcyon for their lifetimes. The home is now owned by the temple. Shown below are, from left to right, Gertrude Tedford, sister Lillian Brown Horskey, and daughter Jean Tedford Doty.

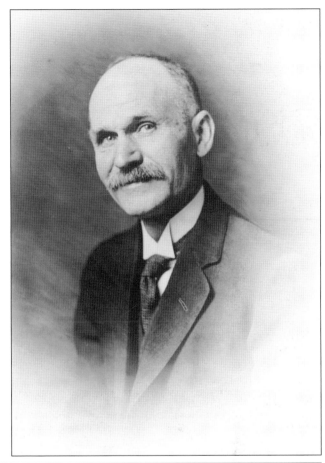

William Townsend (right), an early temple member, built a home for his own use on property belonging to the Elliott-Carlberg family sometime after 1923. The small cottage sat in the middle of a field on the east side of Dower Avenue. Around 1931, he married, which prompted him to move his home across the street to its current location for rebuilding. The unusual shotgun-style home was left to the temple after the couple died. Standing in front of the home (below) is longtime Halcyon resident Flora Wheeler (left), stepmother of Wenona Varian and friend of the Schussman family. Shown with a visiting cousin, she belonged to the temple from the 1920s until her death in 1977.

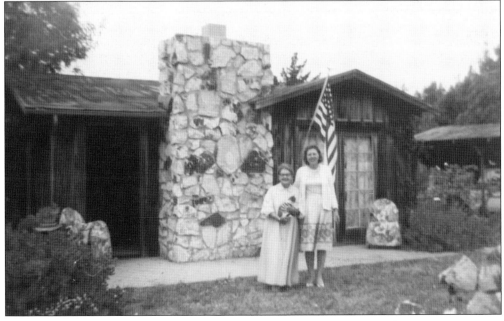

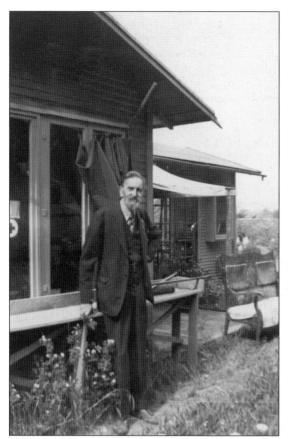

Otto Westfelt (left), known for his lyrical tenor voice, was a tireless worker in the community. A pioneer member of the temple, he came to Halcyon from Syracuse with the first members of the group. He learned about the temple in his native Sweden. Westfelt first lived at the sanatorium, then in several locations in Halcyon. His last home (below) was a modest cottage at the south end of Dower Street that was built about 1920 by Dr. Coulson Trunbull, a noted author and temple member. The land and home were later given to the temple.

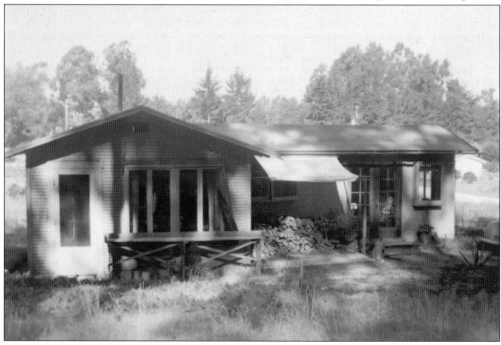

Five generations of the Whitney-Stenquist-Lentz-Clark family have lived in Halcyon in a complex of homes they constructed on temple land just north of the Blue Star Memorial Temple. California native Fred Elijah Whitney learned about the temple and Halcyon in 1911 while living in Palo Alto as a Stanford student. Whitney came to the community four years later, built a small cottage in 1929, and expanded it after his marriage to Ebba Stenquist in 1931. The couple is shown at right sitting on the porch of that home. Ebba's children, Mary Louise and Robert Stenquist, each married and expanded the family (below). From left to right are (first row) Patricia Lentz Bennett holding sister Susan Lentz Clark, Opal Stenquist, and Opal's daughter Joyce; (second row) Herbert Lentz, Mary Louise Stenquist Lentz, and Robert Stenquist.

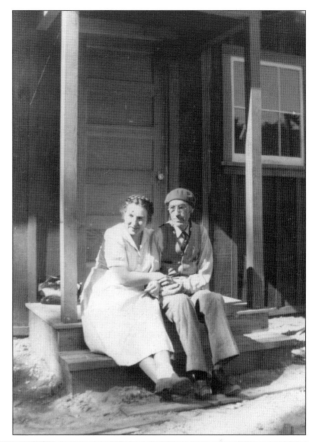

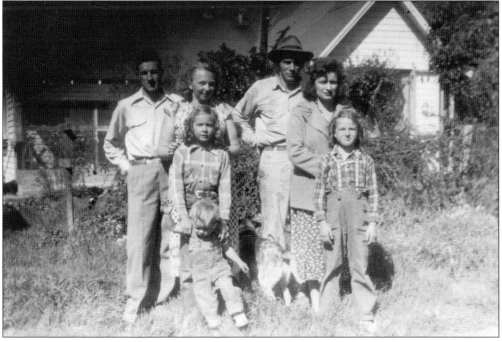

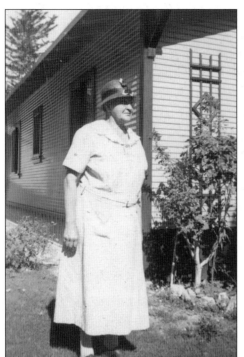

Augusta Riedel Volz joined the temple in 1910 and moved from Washington to Halcyon in 1920 with her son Herman, then 16 years old. In 1926, she arranged for the construction of a redwood bungalow off Temple Street, designed and built by Perry More, who also supervised construction of the Blue Star Memorial Temple. It is the most traditional Craftsman-style home in Halcyon (below). Herman Volz (above right) operated a poultry and egg enterprise on their property with flocks of several hundred chickens. His mother (above, left) is shown before her death in 1952.

Posing at right in front of a thriving palm tree at the sanatorium in the mid-1930s are, from left to right, Fred Wolff, Ida Mae Wilkins, and Bertha Beggs Wolff. Wilkins came from New York State with the first temple members and remained until her death in 1936. Bertha Beggs arrived in Halcyon before 1920 and worked in the temple office. She later met Fred Wolff, and the two married in 1931. Shown below is the redwood home Fred Wolff and his brother Carl constructed about 1932 along Helena Street.

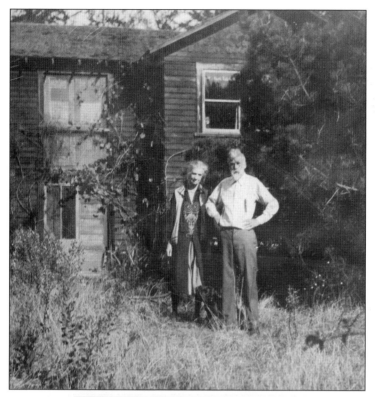

John and Agnes Varian were members of the original temple group in Syracuse. Prior to establishing their permanent residence in Halcyon, they lived for several years in Palo Alto and led an active study group there. Two of the three Varian sons went on to establish Varian Electronics, one of the first companies in what is now Silicon Valley. The Varians are shown at left in front of their Halcyon home off Temple Street and, below, resting on a log.

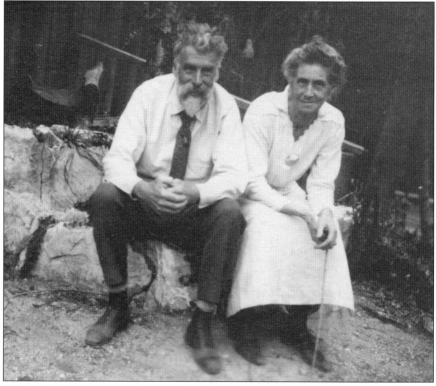

Wenona Tallman Varian, wife of Eric A. Varian, poses with her affectionate dog on the expansive tufa-rock front porch of their home on Helena Street. This redwood home, built in the 1930s, features a large golden stone fireplace to match the porch.

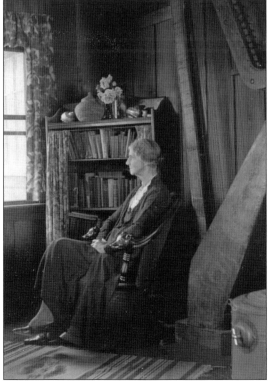

Agnes Varian relaxes in the upstairs study of the home she shared with her husband, John, in the late 1920s. Constructed in 1905, the interior of the two-story structure is paneled in redwood board and batten. The large harp to her right, one of a handful crafted by her husband, now stands in the Blue Star Memorial Temple in Halcyon.

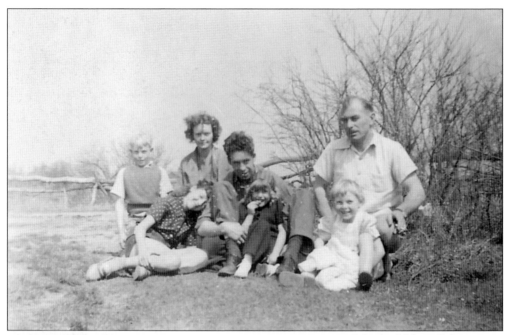

Martha Nelson Schussman and Wenona Tallman Varian were girlfriends together in Astoria, Oregon, and this friendship led the women and their families to Halcyon, where they lived as next-door neighbors. Work in the fledgling electronics field took both families to Brooklyn, New York, and Palo Alto, where they sometimes lived together. By 1944, they settled back in Halcyon for much of the rest of their lives. Shown above are, from left to right, Wenona Varian holding Michael Schussman, Joan Varian Rowlands, Eric Varian holding Sheila Varian, and Ken Schussman sitting behind Mona Lee Schussman Kelly at a beach party around 1940. Shown at left are girlfriends Sheila Varian (left) and Mona Lee Schussman Kelly in the late 1940s.

Young Herman Volz bends to pet his dog in the backyard of his home and poultry enterprise. The picture is not dated, but the truck in the background was obviously built around 1930. His mother, Augusta Volz, stands beside it.

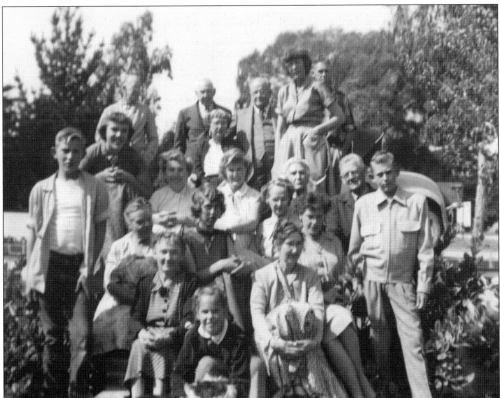

A crowd gathers for a picture in the mid-1950s at one of the community's frequent parties. Following cards and croquet, the group posed on the front steps of the rambling ranch-style Shumway home.

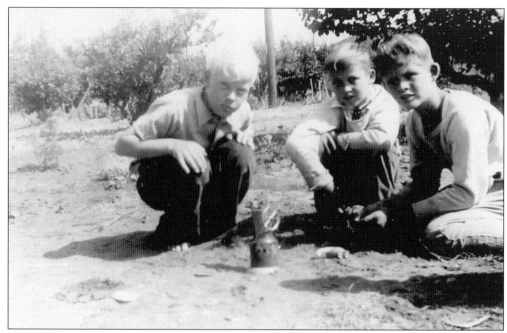

Three young scientists study the workings of a small steam engine in a Halcyon backyard about 1944. From left to right are Michael Schussman, David Mallory, and Vard Long. Schussman became an electrical engineer; Mallory became a musician, artist, and teacher; and Long retired after service in the US Navy.

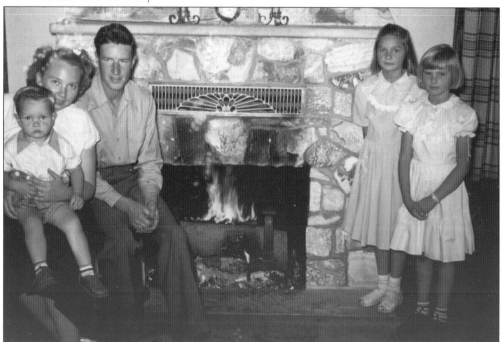

The Lentz family gathers by the blazing hearth for a Christmas photograph in 1950. From left to right are Richard Lentz, Mary Louise Stenquist Lentz, Herbert Lentz, Patricia Lentz Bennett, and Susan Lentz Clark.

Ella Vogtherr arrived in 1923 to visit friends but decided to join the temple and put down roots in Halcyon. Active in theosophical circles in Germany before coming to the United States, she became a temple priest. During her long life, she also served as the temple's secretary, taught the youth groups, and was the special corresponding secretary to the German membership. Shown on the steps of the Blue Star Memorial Temple, she died in October 1967.

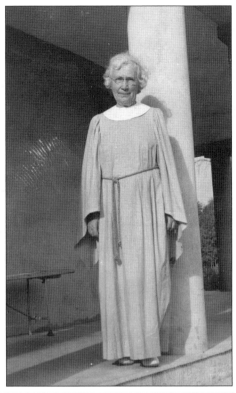

Three generations of the Ross family, for whom Ross Lane in Halcyon is named, stand in front of a garage in the early 1950s. From left to right are Russell Hoff; Lee Ross; his wife, Frances Ross; and their daughter, Olive Ross Hoff. Peeking into the picture at lower right is small Wendy, daughter of Spike Ross, one of Lee and Frances's sons.

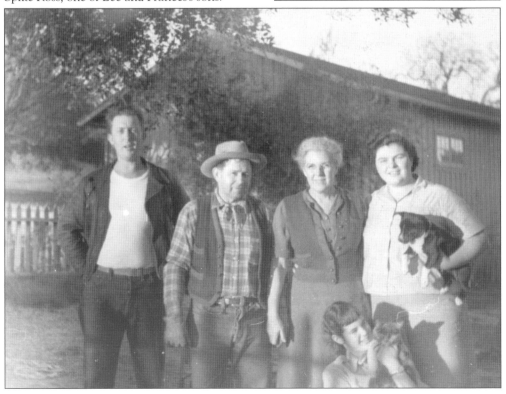

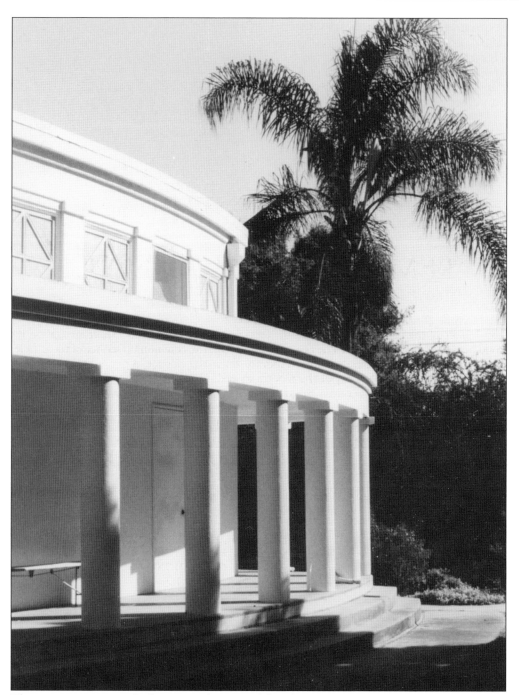

The morning sun casts shadows onto the steps of the Blue Star Memorial Temple. The building's gently curved sides are clearly visible, a result of its convex triangular shape. The porch encircling the building is supported by 36 pillars with a band of 28 clerestory windows above. Each square window is constructed of eight triangular panes of glass.

ABOUT THE
TEMPLE OF THE PEOPLE

The Temple of the People offers services at 10:30 a.m. each Sunday and a short meditation for world healing each day at noon. The Feast of Fulfillment, the communion service of the temple, is celebrated on the first Sunday of each month. Enter the Silence, a prayer and meditation meeting, is held the last Sunday of the month. Speakers present programs on other Sundays. The public is invited to all services. Study classes are held regularly in the temple at 5:30 p.m. on Tuesdays and Fridays.

The William Quan Judge Library serves researchers and those with an interest in theosophy. The library, staffed by volunteers, is open from 9:30 to 11:30 a.m. on Tuesdays and other hours by appointment through the temple office.

Temple books and other publications are available through the Halcyon Book Concern, the publishing department of the temple.

There are temple groups in California, Illinois, and New York; London, England; Moscow and St. Petersburg, Russia; and several locations in Germany.

The Temple of the People
PO Box 7100
Halcyon (Arroyo Grande), CA 93421-7100
Telephone: 805-489-2822; Fax 805-481-9446
www.templeofthepeople.org

DISCOVER THOUSANDS OF LOCAL HISTORY BOOKS FEATURING MILLIONS OF VINTAGE IMAGES

Arcadia Publishing, the leading local history publisher in the United States, is committed to making history accessible and meaningful through publishing books that celebrate and preserve the heritage of America's people and places.

Find more books like this at
www.arcadiapublishing.com

Search for your hometown history, your old stomping grounds, and even your favorite sports team.

Consistent with our mission to preserve history on a local level, this book was printed in South Carolina on American-made paper and manufactured entirely in the United States. Products carrying the accredited Forest Stewardship Council (FSC) label are printed on 100 percent FSC-certified paper.

MADE IN THE